FROM
CHALK TO BRONZE

A Biography of Waldine Tauch

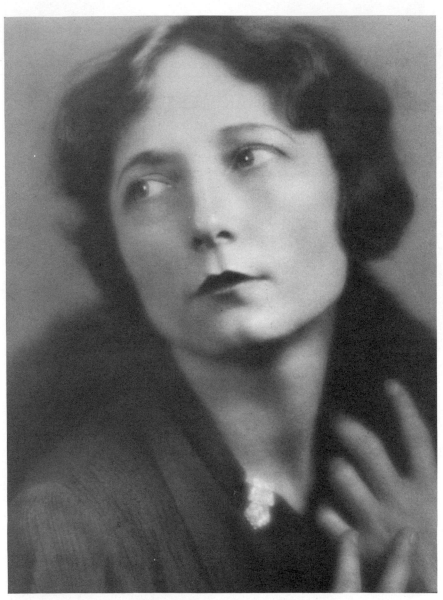

WALDINE AMANDA TAUCH IN 1944.

FROM

CHALK TO BRONZE

A Biography of Waldine Tauch

BY

ALICE HUTSON

Jacket by Vic Blackburn

SHOAL CREEK PUBLISHERS, INC.
P. O. BOX 9737 AUSTIN, TEXAS 78766

First Edition

Library of Congress Cataloging in Publication Data
Hutson, Alice, 1941-
 From chalk to bronze.

 Bibliography: p.
 Includes index.
 1. Tauch, Waldine, 1892- 2. Sculptors —
United States — Biography. I. Title.
NB237.T38H87 730'.92'4 [B] 78-16000

ISBN 0-88319-037-0

To my father

BRUCE HARPER

CONTENTS

ILLUSTRATIONS

PREFACE

This biography is a mixture of truths — for everyone sees the truth differently, and some truths are not seen at all. I have attempted to enter the body and soul of Waldine Tauch so as to know and understand how she felt about things around her and how people, especially Dr. Coppini, affected her. In that respect I have an advantage, for my own father was a great artist with exacting requirements for high quality as well as a temperament expected, and often seen, in men of genius. Yet, I loved him and easily forgave him for the problems his outbursts often caused me. From speaking to many people who have known Dr. Coppini and from reading his autobiography, *From Dawn to Sunset,* I realized it was much the same for Dr. Tauch.

This book is the story of a poor young girl who struggled for recognition, who made a sacrificial covenant in order to receive the training she needed, who entered a zealously protected man's world without the benefit of women liberationists' support. It is also the story of an ageless woman whose already established career began to soar when she was sixty-five; of a woman who refuses to stop for anything, least of all age.

This book is not a memorial, for Dr. Tauch still lives and works in her studio on Melrose Place in San Antonio. Her sculptures will exist for many hundreds of years.

Dr. Tauch has been a close family friend since I was a child; close enough that my sister and I called her ''Aunt'' Waldine out of respect, and now our own children do. I loved and admired her before I realized that thousands of others did, too; so my impressions of her are not colored by celebrity worship, but

by genuine amazement at her talents and her staunch determination to produce magnificent works at an age when her peers have long since retired. I've seen her observe and appreciate the beauty in the world around her and make an effort to ignore any ugliness she couldn't change. I thought I knew her well.

I approached her on the idea of writing her life's story hesitantly, for I had never written a book of this nature and didn't know if I could. However, her exuberance over the idea and her faith in my ability left me no choice. I would write the book. She agreed to extensive interviews and delivered boxloads of clippings, letters, pictures, and memorabilia. I listened to what she said and carefully watched her face to interpret her feelings.

Three years later, and after many revisions, the book is finished. I know her better, understand more clearly why the little lady has such a following of friends and fans, and why her world is filled with beauty and love. It has been a marvelous experience for me, and, I think, a nostalgic adventure for her, another symbol of her success.

Special thanks and gratitude to

John Igo
of San Antonio College

and

Robert Flynn
of Trinity University
for their encouragement and assistance
on this project.

INTRODUCTION

Eyes shining, Waldine Tauch stood in the Texas Senate as the clerk read a special proclamation recognizing her for her contributions as an eminent Texas and American artist and patriot. It was an honor she richly deserved.

Waldine Tauch has through the years fought fiercely for the highest ideals of representational art in both painting and sculpture. When she was elected to the art committee of the Panhandle-Plains Historical Museum (of which I was the director), she was certainly effective in steering exhibits away from abstract work and toward the representational art she so passionately believes in. Her influence resulted in many fine accessions of representational art coming to the museum as permanent gifts. Not only through her own fine sculpture but also through many activities on behalf of other artists, she has brought classical fine art to the public view.

Waldine's idealism and her forceful drive have been evident too in her dealings with the media, the educational system, and governmental organizations. She has always been deeply concerned about all things pertaining to the public good.

Above all, Waldine Amanda Tauch is an extraordinarily talented artist of national stature. She is a truly wonderful woman, admired and esteemed by those who have been privileged to associate with her through the years. Her story must be told.

C. Boone McClure

C. BOONE MCCLURE DIRECTOR EMERITUS
PANHANDLE-PLAINS HISTORICAL MUSEUM

BACKGROUND AND BEGINNINGS

I

UNVEILING THE MASTERPIECE

Born for success [she] seemed,
With grace to win, with heart to hold,
With shining gifts that took all eyes.
— Emerson

SITTING UPON the raised platform, among national celebrities, Dr. Waldine Tauch looked out on the throng at the dedication of the Douglas MacArthur Academy of Freedom. Suddenly, in the midst of General William Westmoreland's speech, Dr. Tauch was shocked and embarrassed to feel tears about to fall. A moment of powerful feeling for her country, as unexpected as it was strong, made her blink fiercely. Soon, however, her eyelids skillfully stopped the flow of tears and she regained her composure, appearing calm and dignified — untouched. In her seventy-seven years she had received much practice in retaining her dignity and hiding her tears, not only tears of joy, but also those of humiliation, loneliness, and sometimes regret.

She studied the thousands of people who stood below her, knowing she was partly responsible for their presence on that windy fall day. Satisfaction warmed her. At that moment she felt assured that her life of struggle, with all its

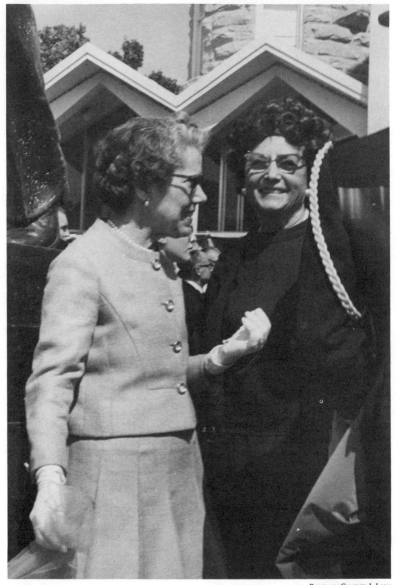

WALDINE EXCHANGES PLEASANTRIES WITH MRS. DOUGLAS MACARTHUR AFTER THE
UNVEILING OF THE "GENERAL DOUGLAS MACARTHUR" AT THE ACADEMY OF FREEDOM
IN OCTOBER 1969.

disappointment and sacrifice, was, in the final analysis, significant. Her memories and regrets grew less painful, less traumatic. With her life she had paid the expensive price of success and now she would bathe in the glory and accept the rewards without shame or false modesty.

Sitting beside Waldine was General Douglas MacArthur's widow. In the crowd were politicians, newsmen, including Paul Harvey who would speak later, university presidents, ambassadors from each of the Allied countries, and proud Americans. It was October 1969 and West Texas winds playfully teased the crowds, blowing hats off and skirts up, and then audaciously blew off the silk parachute which was draping the statue, prematurely unveiling it. Waldine stood in alarm at the calamity, then with tightened lips sat down, perturbed at her helplessness in preventing this dignified affair from becoming a comedy. Workmen scurried about grappling with the billowing cloth while the audience chuckled and giggled at the charade. Waldine felt no humor at the lost solemnity. Anger and indignation boiled within her as she muttered beneath her breath for the men to hurry with their task. However, after they climbed the ladders and replaced the drape, dignity was restored.

Mrs. MacArthur, following her introduction, stepped down from the platform and, as if nothing had been revealed, pulled the cord of the drape to officially unveil the statue amidst loud applause and bands playing triumphantly. Waldine sighed with relief.

The General's widow exclaimed, "It's the best likeness of my husband I've ever seen. Why, it's even better than the one at West Point." Her eyes misted in remembrance.

Waldine overheard her remark and silently agreed, feeling that it was truly her masterpiece. She watched the crowd, pleased with their reaction, wondering if they would notice the many details she had modeled into his uniform, and especially the almost-forgotten ring. She could smile now at the catastrophes which had plagued the completion of her statue: the missing ring, the longshoremen's strikes both on the Italian coast and then in Houston which caused the cere-

mony to be postponed twice. She wasn't paranoid, but she remembered feeling that some unknown and unfriendly source must have been against her and her MacArthur. But it was over now; her unveiled statue — her masterpiece — stood magnificently in front of the Academy of Freedom, and she enjoyed the praises lavished upon her.

Mischief danced in her eyes when a spectator, obviously doubting that such a small woman as she could have created such a large statue, questioned her.

"Why, yes, of course I did it myself. Why do you think I didn't?" she mocked, knowing full well the reasons for his doubt.

"Well," the doubter stammered, "you're so small. You don't look like you have the strength to accomplish such a task." He carefully avoided saying she looked too old, yet she knew it was her age as well as her small size which puzzled the man. She also knew he didn't have any idea of how old she really was, and if he did know he would be even more shocked. But she was not ready to retire — not even then — so she kept her age secret, a private joke she shared with no one.

II

EARLY CHILDHOOD

WALDINE AMANDA TAUCH was born on January 28, 1892, in the German-immigrant town of Schulenburg, Texas.

Her father, William, was a handsome man, tall and lean with thick blond hair, a generous moustache, and eyes that often twinkled in secret amusement. He earned a meager income as a photographer in the days when photographs were a new invention and few people could afford the luxury or the vanity of portraits. His wife, Lizzie, jealous of the young women who naturally happened to be his best customers, disapproved of her husband's occupation. So, when Waldine was three years old and her sister, Erna, was six, he decided to move his family to a farm four miles from Flatonia, Texas, where he hoped to better provide for his family and still have time for photography. To mollify his wife, he concentrated on family groups and landscapes more than portraits.

On the farm, her father often joined Waldine on long walks, always willing to teach and explain to her the secrets of nature, which she was always eager to learn. Together they tore apart a mud dauber's nest so that he could show her the spiders which the wasp had stored inside for food for its young. Together they spied on scissor-tails, prairie dogs, and fat

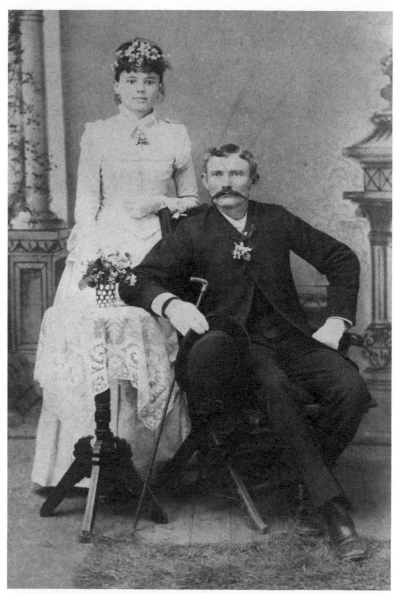

WALDINE'S PARENTS, ELIZABETH HEIMANN TAUCH AND WILLIAM TAUCH, (CIRCA) 1887.

swamp rabbits, and he encouraged her curiosities. She grew very close to her father, for they shared not only a love of nature, but an appreciation of the beauty they found together.

Waldine greatly admired her father's photography, and on rainy days when they couldn't take a walk they spent hours on the couch in the parlor looking at prints of his portraits. One print especially captivated her and she held on to it for quite a while, admiring the grace and beauty of the woman who had posed for the picture. Her blond hair sat heavily upon the top of her head, with curly tendrils falling down gracefully to frame her face.

''Oh, she's so beautiful,'' Waldine sighed, feeling something stirring within her.

''Well, since you admire the lady so much, you may have the print, if you promise to take care of it,'' her father offered.

''Oh, may I?'' she cried out in delight, and to her father's surprise ran off to her room with her treasure, no longer interested in looking at other portraits. In her room, she studied the portrait, not understanding her feelings but knowing that she wanted to somehow grasp the beauty she saw. She felt compelled to draw a picture of the woman and delighted in the warm feeling she experienced as she copied the woman's face on paper, the power she felt flowing from her fingertips, the power of creation.

After that experience she became even more interested in her father's photographs, always searching for another that could inspire her as the woman's portrait had. Her father recognized her artistic talents and stimulated her creative urges with compliments and loans of any picture she wanted to draw.

When she was eight years old, however, her brother, Charles Werner, was born, and her father spent so much time admiring and photographing his son, he didn't seem to have time for her. She resented the intruder who robbed her of her father, and she often sulked in her room. Without her companion she spent more of her time drawing, not only copying photographs, but attempting to draw from memory pictures of the animals she and her father had enjoyed. But then, remembering her abandonment, she wadded them up or tore them to shreds in silent protest.

Her father soon realized his neglect and on one of his trips to town for supplies purchased a book, *Chapp's Photographs of the World,* which he shared with Waldine. Photographs of breathtaking landscapes and quaint villages filled most of the book, but the pictures of famous paintings hanging in equally famous museums and close-ups of statues gracing foreign plazas awed and intrigued her. She borrowed the book and drew pictures from it to give to her father; presents to thank him for his reassurance of love.

Waldine thought it would be fun when her father decided to have her and Erna help him develop and print his photographic plates. Watching the pictures appear as if by magic on the white paper fascinated her, but mostly she enjoyed being the first to see the prints and preview them in search of one to draw. The fun, however, soon wore off and the job became tedious, imposing upon her time for walks and for drawing, but she didn't complain for she knew her father needed their help.

However, even with his daughters' assistance, William Tauch found he had little time to devote to photography, and trying to support his family on the farm proved more difficult than he had imagined. A drought dried up his crops and killed some of his cattle. An epidemic of cholera killed most of his herd of pigs. The dead animals were burned the next morning to keep the infection from spreading. Trying to supplement what little he earned from the farm, he and his brothers pooled their money and opened a cotton gin. The first year the gin succeeded, but the following year boll weevils destroyed the cotton crops, causing the gin to go broke. In addition to the financial crisis, Waldine's father contracted malaria and often had recurrences of the disease which prevented him from carrying on the necessary farm work. Their parents decided it would be best for the girls, who were attending school in Flatonia, to spend the school nights in town with their cousins rather than walk the four miles every morning and again in the afternoon. Waldine felt alone in Flatonia and missed her father painfully, while he felt he had abandoned his children. When she was ten years old, William Tauch, totally disillusioned and disgusted with farm life, decided to move his family back to Schulenburg. His family could be together again, and he hoped

that times had changed so that he could make a decent living with his photography.

Erna and Waldine enrolled in the Catholic Sunday school. Although they were not Catholic, at that time it was the only church in town, and even Protestant and Jewish children attended. Impressed with the statuary in the chapel, she often received the scorn of the Sisters for not paying attention, but she felt certain God did not object to her admiration of beauty.

Without the many farm chores, Waldine had more time to draw pictures and began drawing from real life. She drew portraits of her new friends and received their admiration and praise. After school, her teacher often asked her to draw from her history book upon the blackboard, which she eagerly did, pleased that she had been asked.

As much as she enjoyed drawing, she grew more fascinated and intrigued with statues and yearned to experiment in modeling, but she knew there was no money to spare for store-bought clay. Frustrated by her inability to satisfy her desperate desire to create, she was astounded one day while working in the backyard garden to discover how the soil seemed to stick together when it was wet. She reached down, grabbed a handful of the black dirt, and squished it in her hand, concentrating on its texture as she did. The dirt stuck together and stuck to her hands as well. With delight she scraped to get it off her hands. She had found her clay!

She discovered the black clay worked well in her hands, was easily molded into shapes, and held its shape as it dried and hardened. She eagerly modeled small heads and figures, animals, and angels complete with spreading wings. However, she was disappointed in the lack of detail of her figures and searched for other substances which would allow her more creative freedom. Her mother suggested carving on soap and her father loaned her his pocketknife. Carving offered her a new outlet for artistic expression and possibilities for using other substances. She experimented on wood and chalk, and even on a broken piece of a statue her cat had knocked off a table.

One afternoon when Waldine came home from school, her mother and a close friend, Miss Minnie Hoeffert, were sitting in the parlor admiring a small ivory bookmark with an intri-

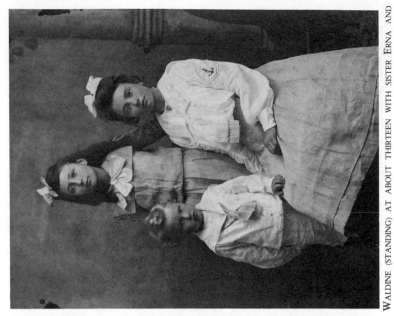

WALDINE (STANDING) AT ABOUT THIRTEEN WITH SISTER ERNA AND BROTHER WERNER.

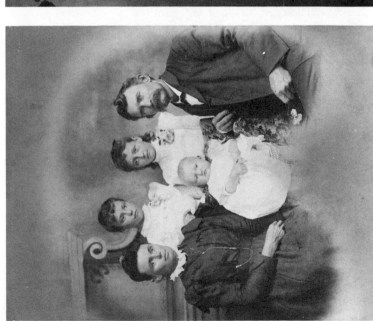

WALDINE (CENTER RIGHT) AT ABOUT TEN WITH SISTER ERNA, BABY BROTHER WERNER, AND PARENTS.

10

cate hand-carved figure. Miss Hoeffert's fiancé had sent it from Germany, and she proudly showed it to Waldine. Never had the child seen anything so artistically beautiful. She was so impressed she decided to make one like it. She carefully studied the details, both with her eyes and with her fingertips, attempting to memorize the carvings precisely.

The next day at school she begged for and received from her teacher a large piece of the chalk used in those days. When the bell rang, she ran eagerly home to begin her project. She had never carved anything so delicate or intricate, and the challenge stimulated and excited her. She wanted very much to make her carving as precise and beautiful as the one on the bookmark, so she worked slowly and cautiously the entire afternoon and into the evening.

When she finished, she was surprised at her own skill and ran to show her family. Her mother called in the neighbors, and soon Waldine was besieged by requests for carvings similar to the bookmark. She accepted their requests as compliments and enjoyed that touch of glory so much that as she worked on the carvings for her friends, she began daydreaming of becoming a famous sculptor with her statues in museums, parks, and plazas. But she knew it was only a dream. Her family was not affluent, and without money there was little chance for her to receive the recognition for which she so yearned.

While Waldine was enjoying the taste of success, her father faced another disaster. Photography still was not profitable enough to support his family. Exasperated by arguments with his wife and depressed at facing yet another failure, he began drinking to escape his problems. Her father postponed the inevitable for as long as he could but finally, in utter defeat, gave up and accepted the generous invitation of his brother-in-law, Traugott Heimann, to live with him on his ranch.

At fourteen, Waldine did not look forward to moving to her uncle's ranch 200 miles away. She had made close friends in Schulenburg, and the ranch was so far away. She knew she would never see them again. She enjoyed living in town where she at least had some opportunity for recognition, and she dreaded the isolation of a ranch. But mostly she grieved for her

11

father, who loved photography as much as she loved art and would now have to give it up. Waldine partially blamed her mother for not supporting him more than she did, but she said nothing as she quietly helped her mother and sister pack their belongings into the large trunks. She insisted on taking charge of packing her father's photography equipment and took great pains to insure that it was all carefully wrapped so that nothing would break or be damaged. Her own carvings and art work she wrapped and tucked in close to her father's equipment. She thought sadly how unimportant those things must seem to others, yet she knew that for her father and for herself part of their souls were being packed away, and the job must be done with love and care. She tried not to think of the uncertainty of the future.

III

AN ELUSIVE DREAM

AFTER A long and arduous trip, first by train and then on a rickety old chuck wagon, the family arrived at the ranch late at night. Uncle Traugott, proud of his new home, which wasn't quite finished, but livable, insisted on giving the Tauchs a tour. Waldine dutifully followed the others, too exhausted to be very interested, until they entered the dining room. She caught her breath in astonishment, for although the room was narrow, it was quite long, and stretching the length of the room sprawled a table which could seat many people.

She awoke early the next morning and found her uncle and father in the dining room sipping cups of steaming coffee with two men who drove the mail hack from Menardville every day. Her mother invited them to stay for breakfast, and from that day the drivers and their occasional passengers were always welcomed. The custom eventually shaped Waldine's future and her entire life.

The busy activities of ranch life eased her grief for her lost friends, and soon she resumed drawing, carving, and modeling. On exploratory excursions around the ranch she discovered to her delight that the natural clay soil was ideal for modeling, at least far superior to the black clay of Schulenburg, and for carving she found sandstone. A friend sent her some green

soapstone, which gave variety to the color and texture of her sculptures. Her collection grew so large that her father built long shelves in the dining room to display her small works. Waldine's exhibit became the topic of many breakfast conversations, drawing compliments from friends and visitors, especially after they learned the talent belonged to a young schoolgirl. Because her exhibit continued growing rapidly, she occasionally gave visitors a sculpture to make room for others. However, one stranger astounded her by insisting upon paying her a few coins for one of her works, and the unexpected offer flustered and embarrassed her. She had never considered selling her work, but from his offer a dream of fame and fortune emerged once again, giving her an impetus to work harder at perfecting her skill.

One morning two women from Brady, Mrs. F. W. Henderson and Mrs. John Shaeg, arrived at the ranch. "We've heard so many rumors of a child who carves and models figures that we were curious and wanted to see for ourselves," Mrs. Henderson explained.

Mrs. Tauch, still wearing her apron, noticed with discomfort the fine cut of the women's clothes, their expensive hats, and the dignity with which they carried themselves. Perplexed by the unexpected visit, she nevertheless led them into the dining room and proudly showed them the shelves of sculptures, feeling more at ease as their compliments flowed, while Waldine stood aside, blushing at their praise.

"Your daughter indeed has a viable talent, Mrs. Tauch. Everything possible should be done to develop it," stated Mrs. Shaeg.

"Well, yes, of course," Mrs. Tauch agreed. "We encourage her all the time."

"That's not enough. She should receive art lessons. Her talent needs to be guided and developed by a professional," Mrs. Henderson insisted.

"Well, that would be nice, but as you can see, we are a poor family. Art lessons are simply out of the question," Mrs. Tauch replied, remembering self-consciously the apron she wore, knowing these women never wore aprons and never had difficulty sending their daughters to the finest schools in the

world. Her own children would receive no more than a public school education, and she wanted to stop these women from building up Waldine's hopes of a grandeur which could never be. After all, one must be realistic.

"If you only lived in Brady," mused one of the women, but Mr. Tauch entered the room just then, interrupting her comments.

"These women came all the way from Brady to see Waldine's sculptures. They've got a notion we should send her to art school," his wife scoffed.

"I started to say before you came in that if only you lived in Brady, perhaps our club, the Brady Tuesday Club, could raise funds for her art education," Mrs. Henderson explained.

"Brady, eh?" her father repeated to himself, while Waldine stood aside as a silent observer, her stomach churning in excitement at the possibilities the women were hinting at. Could her father actually consider moving to Brady just for her, she wondered, marvelling at the idea but hesitant to believe anything as fantastic as that could happen.

"We'll have to give that some thought," her father replied, surprising both his wife and daughter.

"That's all we can ask. Do let us hear from you soon," Mrs. Henderson replied as the women were escorted to the front door. "If you decide to come, I assure you the move will be well worth your while."

Waldine's father felt honored that two wealthy women were so interested in his daughter and recognized the move as a marvelous opportunity for her. He could find no reason to refuse her and thought, too, that perhaps in Brady he could get back into photography. Her mother, however, had several reservations. Going through the change of life made her nervous about many things, and she knew of her husband's desires to return to photography. She didn't think she could bear his being so near young, beautiful women when she herself felt so old. Yet, the women's offer pleased and flattered her, too, and she thought of the female companionship and the social life she would have by living in town again. She did miss that.

For days the household buzzed, first with reasons why they should move, then with reasons why they shouldn't.

Waldine listened as her future was batted back and forth, pleading silently with her eyes. She could concentrate on nothing else, not even on the art work which was responsible for the turmoil. So overpowering were her yearnings that she nearly became ill.

"Waldine," her father addressed her one morning at the breakfast table, "your mother and I have made our decision." She held her breath, not daring to hope. "We'll move to Brady!"

"Oh, papa," she screamed, running around the table to throw her arms about him. "Thank you, thank you. I promise you'll never be sorry. I'll work hard. You'll see."

"Now, now. That's enough. We know you won't disappoint us. You'd better thank your mother, too."

"Oh, yes, thank you both so much." She danced around the table, hugging her mother, then her uncle, and even her sister and brother. "I'm so happy," she sang. "You don't know how happy you've made me."

"Well, we're certainly getting an idea," her mother said. "Now sit down and eat your breakfast, or you'll make yourself sick." Her words sounded like a scolding, but Waldine saw the twinkle in her mother's eyes and knew she shared her joy.

Waldine worked enthusiastically, helping her mother pack their belongings and giving her uncle's house a thorough cleaning, knowing that without any women in the household it would not often be cleaned. News of the Tauchs' imminent departure spread quickly in the rural community, and friends constantly dropped by to offer congratulations to Waldine and to invite the Tauchs for one last meal before they left. As eager as she was to leave, Waldine knew her obligations to her friends, and sharing her good news with them only heightened her excitement. One day shortly before they were planning to leave, Waldine, Erna, and Werner took the phaeton, the family's small, lightweight carriage, to visit one of the neighboring ranches to say their farewells. Happy with anticipation, on their return they sang rollicking old German songs.

As they neared their uncle's house, a herd of cattle passed in front of them; however, their horse was trained to walk

through herds of cattle without being alarmed. The children were able to continue their journey, waving at the cowboys on horseback who kept the cattle from bumping into the carriage. When the children arrived at the ranch they were puzzled and alarmed to find their mother in a state of hysteria. They soon learned, between their mother's uncontrolled sobs and frantic screams, that she had seen the dust from the cattle and thought her children were being trampled to death. Realizing what had gone through her mind, they all tried to assure her that they were safe and unharmed. Even so, it was quite a while before she calmed down.

When she appeared completely recovered, she went into the kitchen to prepare dinner but stopped in the middle of what she was doing and asked Waldine to come outside with her. Waldine obeyed her mother's puzzling request, hoping to receive an explanation outside. Perhaps, she thought, her mother wanted to reassure her of her expectations or give her some sort of a pep talk about her future.

However, a few yards away from the house her mother stopped, pulled out a butcher knife she had hidden beneath her apron, and raised it to her own throat. Waldine watched her performance in the bright moonlight, unbelieving, then screamed in terror as she saw the well-honed edge of the knife slice quickly across her mother's throat, letting blood spill forth in an impatient, deathly gush. A cowhand overheard her screams and raced to Waldine's mother, gripping Mrs. Tauch's arm and forcing her to release the blood-smeared knife. Mr. Tauch rushed from the house as the knife dropped to the ground and caught his wife as she went limp, lifting her into his arms. He ordered the cowboy to ride to the neighboring Wilhelm ranch to telephone for a doctor, then carried his wife into the house. Waldine followed quickly behind, her mind racing over what had happened, searching for a reason, and fighting her nausea. In a state of near-shock she tried to explain to her father what had happened while he acted quickly to stop the bleeding on his wife's mutilated throat.

Hours later the doctor arrived, stitched the deep slash closed, and medicated and rebandaged Mrs. Tauch's throat. "Luckily, she missed the jugular vein or she wouldn't have

survived,'' the doctor announced solemnly. He promised to return every day until she was well.

Even though the wound healed properly, the doctor sadly reported that Mrs. Tauch had completely lost her mind and recommended that she be committed to the insane asylum in San Antonio, for there was no hope for her recovery.

Guilt tormented William Tauch, for he knew his drinking problem caused his wife's nervousness. Blaming himself for her present condition, he stubbornly told the doctor that he would nurse her back to health. The doctor tried but could not dissuade him from his self-appointed mission.

Waldine knew without being told that the accident — she preferred calling it that — ended her own glorious plans, for they would not move now, and she felt a deep, torturing sense of guilt for her selfish thoughts. With a weight of weariness and defeat she unpacked sadly what had been packed in gaiety and expectation. Hopelessness filled her aching heart, not only for herself and her lost chance, but for her mother as well, for both their lives seemed equally wasted.

Mrs. Tauch did not recognize her husband or any of her children, but William Tauch took his wife for daily walks, read to her, and spoke patiently and lovingly to her. He quit drinking and turned to the Bible for strength. Each day he showed her pictures of himself and their children, naming each child as he pointed, hoping for some sign of recognition, but she only stared vacantly at the pictures. Six months passed with no sign of improvement, and the doctor's prediction seemed to be true. Waldine often saw tears in her father's eyes, but there was nothing in her mother's, and she wondered if her father was hopelessly punishing himself. She cried for him at night, silently into her pillow.

One day as her father brought out the pictures, Waldine watched how lovingly and tenderly he pointed to each one, naming the person in the photo and waiting patiently for a reaction. There would be no reaction, she knew, and sadly looked toward her mother. Her eyes widened, but she couldn't speak. Staring at her mother, she grabbed her father's arm and shook it. He looked up at his daughter, then at his wife, whose brow was wrinkled in concentration. The first display of emo-

tion she'd shown! Quietly but full of expectation, father and daughter waited, and watched. Slowly Mrs. Tauch pointed to one of the pictures and hesitantly spoke, "Werner." Her first sign of recovery filled the family with joy and a revitalized hope. The doctor had been wrong!

Very slowly and often with a great deal of frustration, Mrs. Tauch regained her memory, and the doctor suggested that the family reconsider the decision to move to Brady. They did move, and Mrs. Tauch responded well to the active life in town, where she improved more rapidly from her traumatic experience.

Several months after the Tauchs' arrival in Brady, the town began plans for its annual county fair, and her mother encouraged Waldine to enter some of her own work in the fair. Waldine shyly hesitated, so her mother selected the figures she considered best, placed them in a box, and carried them to the fairgrounds herself.

Early the next morning Mrs. Henderson came to see Waldine. "Waldine, I'm head of the dairy department at the fair this year and I need something extra special. I've brought two pounds of butter and I want you to carve me something out of it for the exhibit."

"In butter?" Waldine remonstrated. "But I couldn't possibly. The butter would melt before I finished."

"Now I won't take 'no' for an answer. I'm sure you'll think of a way. Now I really must be going," she finished, handing the package of butter to Waldine, who couldn't muster the courage to say 'no.' The warm butter was already melting in her hands. She felt like crying.

Waldine confided to Erna the impossible task she had been given and begged her sister for a solution. Erna contemplated the problem for a moment, then put some ice in a cloth bag and held it over the butter. As the ice slowly melted, it dripped upon the butter, keeping it cold and firm, and Waldine was able to carve an intricate figure of an old-fashioned lady churning butter.

Waldine and several other young people missed the opening of the fair to take advantage of an offer to earn money picking cotton. As they strolled slowly home that evening,

WALDINE IN HER TEENS.

WALDINE AT EIGHTEEN LOOKS FORWARD TO MAKING HER DREAM COME TRUE.

WALDINE AS A TEENAGER IN A PENSIVE MOMENT: DURING THESE YEARS DREAMS OF HER FUTURE SEEMED TO ELUDE HER.

tired but richer, Werner ran toward them, crying out and waving something in the air.

"Waldine, Waldine. You're famous," he said, excited and breathless, as he shoved a newspaper into her face.

A picture of her butter statue greeted her on the front page and below it an article about her, the sculptor. Her friends crowded around her to see, and she felt like a celebrity, though she didn't agree with her brother that she was actually famous. Her chest nevertheless heaved with the excitement of her first write-up, her first taste of fame.

When the fair was over, the Brady Tuesday Club began seriously raising money for Waldine's education. The women sold homemade cakes and candies, held dinners, and produced plays. The community supported all of their endeavors, approving of the club's plans for Waldine.

Mrs. Henderson wrote to Mr. Pompeo Coppini, a well-known Italian-immigrant sculptor whose work she greatly admired. He lived in San Antonio, but when the letter was sent he was in Kentucky, finishing an equestrian statue of General John H. Morgan for the Daughters of the Confederacy.

Mr. Coppini responded: "No! Girls are not good pupils. They work one or two years, then quit. They get married. I lose all my labor."

Mrs. Henderson, a strong-willed woman who usually got her way, couldn't accept his rejection and began a one-woman campaign to change his mind. She sent a barrage of letters, each one insisting, "Waldine will not disappoint you. At least you must look at some of her work."

He finally consented to consider Waldine, mainly to get Mrs. Henderson to stop bothering him. He demanded that Waldine send him a sample of her work to be used as the sole basis for his decision to accept or reject her, and that his decision would be final.

Mrs. Henderson, encouraged by Coppini's concession and confident that Waldine could live up to the challenge, urged her to do something really special. Waldine knew everyone depended on her to impress Coppini and that to do so her work must be exceptionally good, since the great sculptor did not really want to take her as his student.

Waldine decided her sample should be small enough to be easily mailed, yet intricate enough to be impressive. Her subject would be a grouping of the characters from the fairy tale "Little Red Riding Hood." She made her piece only two inches high, but complete in every detail. When she was finished with the sample she wrapped it in cotton batting and placed it in a small box, then placed that box inside a larger one with more cotton batting. She mailed the package, then faced her hardest task: waiting for his reply.

When Coppini received the box, opened it, pulled out the padding, and found still another box full of padding, he thought at first that a trick that been played upon him. But when he finally reached the tiny piece, he accepted her immediately, telling his wife, "Anyone who has so much patience and talent without ever having any training will certainly make a fine student."

STRUGGLES AND SACRIFICES

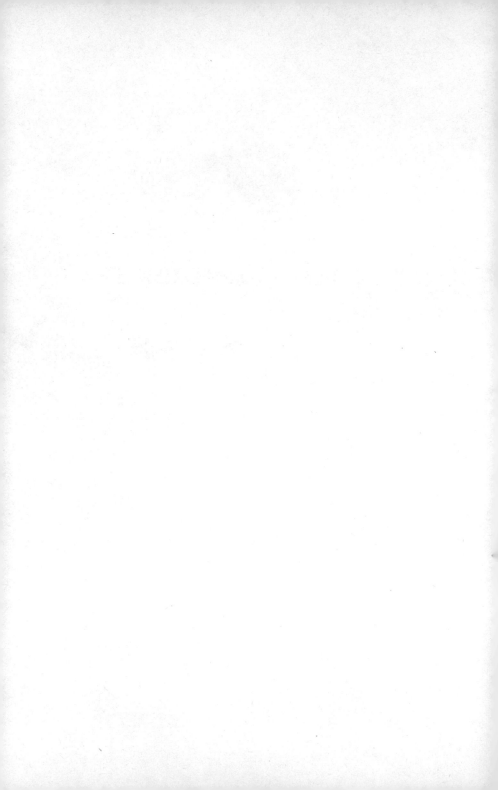

IV

HUMILITY AND FRUSTRATION

COPPINI REQUESTED that Waldine come to San Antonio on June 10, 1910, just a few weeks before she graduated from high school. Her mother protested, "You should write him and postpone the trip. Tell him you can't come until you graduate. What difference can two weeks make to him?"

But Waldine feared a postponement might change Coppini's mind and argued, "Mother, two weeks won't make me any smarter, and I'm too excited to concentrate on my studies anyway. I have my education. I don't need the graduation ceremony to prove it, and I can't risk angering Mr. Coppini."

Not convinced of the triviality of graduation, her mother nevertheless relented.

Her mother was not the only reluctant person in Waldine's life. Her boyfriend didn't want her to postpone the trip — he wanted her to forget it altogether, and he tried to distract her with proposals of marriage.

"All my life I've dreamed of an opportunity such as this. How can you ask me to give it up now when you know how important it is to me?"

"More important than I?" he asked, dejected and hurt by her refusal.

How could she tell him that to her nothing was more important than art? She didn't want to hurt him. "But we can marry later, when I return," she offered in consolation.

He did not give up so easily, and even his mother tried to convince her to marry her son and forget the adventure. Her own mother sided with them, for she was a practical woman and feared her daughter was making a serious mistake by refusing the chance for marriage, perhaps the only chance she would ever have. Their combined efforts to pressure her into marriage before she was ready frustrated her, for they refused to understand her view or be concerned with her interests. Controlling her anger at his selfishness, she broke off with her boyfriend, giving him no promise or assurance that she would ever return. Determined to seek the success of which she dreamed, she stubbornly refused to commit herself to anything else, or to anyone.

With a sigh of resignation, her mother accepted Waldine's decision and busied herself with sewing a suitable wardrobe so her daughter could arrive in the city in style. Friends gave her many going-away gifts, mostly clothes, and the women of the Tuesday Club shopped for her. When she began packing she found she had so many new clothes she could barely fit them all into her suitcases.

Mrs. Henderson sent a telegram to the Coppinis telling them what time Waldine's train would arrive. On the day of departure her father pinned a red carnation to her dress for identification, and her family escorted her to the depot with a huge parade of friends following. As she waved to them through her window, the size of the crowd impressed her, and suddenly the extent of their great expectations became frightful. The weight of her responsibility settled in the pit of her stomach, and a lump grew in her throat. She knew if she were a success she might never see those beautiful, loving people again; if she failed she could never face them.

The train sounded its whistle as it lurched forward; too late for second thoughts. Her stomach grew tight with apprehension as she realized she had never been away from her family. She tried to recall the warm excitement of her dreams, but felt only the cold fear of reality. She felt alone, so utterly

alone, as she traveled to the big city to meet a stranger and live in a strange house. Would she actually become a fine sculptor, as she hoped? Or was her mother right in urging her to marry and forget her dreams? Nagging doubts and a fear of failure clouded her dreams of success, and during the long, lonely trip she felt her confidence ebbing; she felt very small and insignificant.

When the train pulled into the Southern Pacific depot in San Antonio, Waldine hesitantly stepped off and searched the platform for anyone wearing the agreed-upon red carnation. When she saw no one, she tried to assure herself that whoever came to pick her up would likely be waiting inside, away from the scorching heat of the afternoon sun.

She walked through the depot several times but found no one wearing a red carnation. Something is wrong, she thought, and decided to telephone the Coppinis. Why didn't you think of that sooner, she chided herself. There's probably a simple explanation. However, the Coppinis had only recently moved into their new home, and the operator found no telephone number for them. With a sinking heart, she paced the lobby nervously, worrying about the impending darkness. She thought perhaps they didn't receive the telegram, but what was she to do? She pondered her problem, but in her anxiety could find no solution.

Close to tears after hours of fretting, she saw two tall, robust women hurry into the station. They both wore red carnations! Introductions, apologies, and explanations spilled forth in a rush. Mrs. Coppini had received the telegram, but, unknown to Mrs. Henderson, San Antonio had more than one depot. She and her friend had been waiting for hours at another one, wondering and worrying themselves about what had happened to the girl. They all laughed in relief at the error.

The women helped Waldine gather her suitcases, then boarded a trolley car to take them to Madeline Terrace, the home of the Coppinis on the corner of Arcadia and River Avenue (which was later renamed Broadway). Waldine stood in amazement at her first sight of the two-story mansion, for it reminded her of pictures she had seen of Italian villas, the moonlight softly illuminating bas-reliefs high on the outer

walls. Even the pinks, reds, and yellows of sleeping roses faintly glimmered in the night, promising a magnificent sight in the early morning sun.

Pompeo Coppini, looking every bit the Italian sculptor, with thick wavy hair already graying at the temples and a prominent Roman nose, still wore his sculptor's smock as he sat impatiently on the steps outside, rising as the women came into view.

"Well, at last! Here's our young lady." He extended his hand to Waldine in welcome, and as they shook hands she was surprised to find his were soft and smooth, like a sissy, she thought. Clay had already sucked the moisture from her hands and their dry roughness at once embarrassed her.

"Why are your hands so soft? Doesn't clay dry them?" she asked, then regretted her impudence.

"Petroleum jelly," he replied, not in the least insulted. "To a sculptor, his hands are most important. If you don't take care of them, they'll dry and crack. Then they become sore and you can't do good work if your hands are in pain. Every day when I finish with the clay, I coat my hands with jelly. You must do the same or your hands will become worthless."

Ashamed of her obvious neglect, she felt uncomfortable during his lecture, as if she were being scolded like a school-child.

"Enough talk," Mrs. Coppini interrupted, to Waldine's relief. "It's late and we've not eaten."

"Mrs. Henderson wrote that you have no plans to marry," Coppini questioned while they ate a late supper.

"No, sir. I broke up with my boyfriend before I left."

"Ah, but that was just one boyfriend and you are still quite young. Women work hard; they are wonderful students, but then they get married and that's the end. You're not going to do that, are you?" he asked accusingly.

She was unprepared for his interrogation, but being aware of his antipathy for teaching young women, she carefully worded her answer. "Mr. Coppini, since I can remember, I've had an itch in my fingertips to create. While other little girls played with dolls, I modeled my own. While other girls

dreamed of boys, I envisioned my statues in parks and plazas. They dreamed of being wives; I willingly gave up marriage to become a sculptor. I've come to you to study, to work, and to do whatever you ask me in order to make my dream come true, to become a sculptor. I can tell you only how I have felt, and how I feel now. What I will feel in the future, or what I will do, I cannot say, but I cannot imagine my life without art.'' As she spoke, she felt her enthusiasm mounting and her old confidence revitalized.

Coppini laughed, ''What an impressive speech. I like your determination, and if you will study and work hard I can make you a great artist.'' His expectations thrilled her, washing away her earlier doubts and making her more determined than ever to shape her dream into reality and to give her family and the people in Brady good reason to be proud of her.

Although disappointed that since it was so late, a tour of the studio and gallery would have to wait until tomorrow, she had to admit she was exhausted. Mrs. Coppini led her up a great stairway, down a wide hall, and into a large, elegant bedroom furnished with fine old furniture and thick rugs. Servants had already carried her baggage upstairs before they retired. She delighted to see that her room had a small balcony behind the French doors, straight out of Romeo and Juliet, she thought, feeling quite like a princess herself.

Mrs. Coppini, obviously pleased at Waldine's reaction, stayed to help her unpack. She liked Waldine and, having often felt the emptiness of being childless, looked forward to having a young person in the house, someone to chat with whenever work or civic activities monopolized her husband's time.

The next morning a red cardinal perching upon the curved concrete rail of the balcony woke her with his song. She studied him for a moment before she rose and opened the doors, watching the bird soar above and away. The perfume of fresh roses mingled with the sweetness of honeysuckle and drifted gently up to fill her nostrils, reminding her of last night's promise of beauty. She looked down upon the gardens filled with magnificent oaks, each encircled lovingly with colorful flower beds of violets and more roses. Beneath the balcony was a long trellis covered with blue morning glories

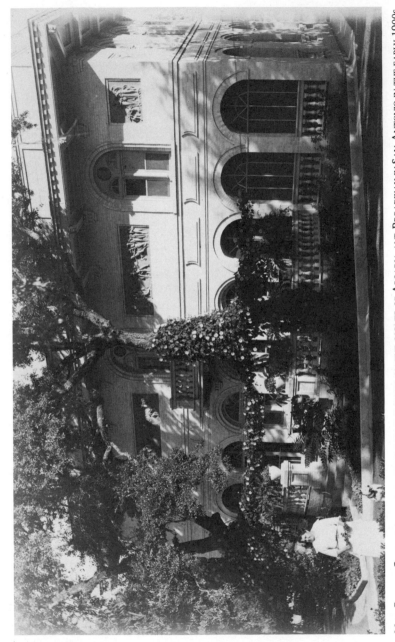

Mrs. Pompeo Coppini in front of their palatial home on the corner of Arcadia and Broadway in San Antonio in the early 1900s. Their home later housed a girls' school, then was demolished in the name of progress.

and rare yellow ones imported from Mexico. Roses of all colors climbed the walls, one vine so near she could pluck a rose from where she stood. She realized the Coppinis loved beauty as much as she and hoped that someday she could share this beauty with her father.

She dressed quickly and went downstairs to eat a quiet breakfast with the Coppinis. When they finished their second cup of coffee, Coppini rose from his chair, announcing it was time to get to work. He led the way and she eagerly followed, anxious to see the working room of a professional sculptor.

The studio was a huge, imposing room over two stories tall with skylights on the whole north side shedding warm, natural light down upon his nearly completed statues. Sam Houston, on horseback in high bas-relief, faced her with pride and dignity, and Coppini told her the work would be placed over Houston's grave in Huntsville, Texas. The original cast would later be given to the Daughters of the Republic of Texas to be housed within the Alamo.

Narrow, long shelves lined the left wall and overflowed with a littered array of tools and small statuary, some of which had served as models before Coppini created the full-sized monuments. A pile of pipes and wood scraps cluttered the floor against the back wall, arousing Waldine's curiosity, but she resisted the impulse to comment on the mess.

Coppini, however, noticed her perplexity and laughed, "What's the matter, you don't like my junkpile?"

"No, sir. I mean, yes, sir," she stammered, not knowing quite how to reply. "But what is it for?"

"Well, you might say that's my bone pile. You see, large statues, like the Houston over there, need skeletons to hold them together the same as you and I. Ours are made of bones; theirs are of pipes and wood strips. Without a skeleton the clay would never keep its shape. But you'll get into that much later. Let's go into the gallery."

They climbed the steps to the right, which led up into the art gallery where Coppini exhibited many of his smaller works and some of his paintings. To one side of the room was an alcove with the full-sized monument of the "Victims of the Galveston Flood," with a skylight above and wooden benches

placed around it for visitors. An outside entrance led visitors directly into the gallery without entering the studio.

He let Waldine study his displays for a brief time, noting and appreciating her admiration, before he opened a door which led into the small room where she would be working. Inspired with what she had seen and eager to begin, she wondered what kind of statue she would be doing first. With difficulty she hid her disappointment when she realized he didn't intend for her to do any sculpting; at least, not yet, for he set up an artist's easel and attached huge sheets of drawing paper. He placed plaster models of eyes, ears, noses, and other parts of the head on a small table for her to draw, then left her alone in the room to draw them. It would be impudent, she decided, to explain to him that she could already draw very well, and so she began her sketches with confidence.

Hours passed and she wondered if he would ever return to see her work. Not until lunchtime did he come into her workroom. When he did, she stood back, quietly awaiting his praise. Proud of her drawings, for she knew they were good, she was startled and more than a little frightened when he took a rag and, slapping the paper, dusted all the charcoal off the paper, completely obliterating her drawings.

"They aren't good enough," he said impatiently. "You'll have to do much better than that if you expect to become a sculptor."

She swallowed hard, blinking back tears until he left the room, and then she let her tears flow freely. Accustomed to praise, not criticism, her vanity was hurt deeply. But as her wounded ego began to heal, she became angry with herself and fiercely resolved to reach for that higher plateau of perfection, one that would please and satisfy even her tough taskmaster. She'd show him! She *would* receive his praise, she told herself firmly, as she grabbed her piece of charcoal and began her new sketches.

For several days she stubbornly stood at her easel attempting to draw to Coppini's satisfaction, wondering if she would ever please him. He destroyed more of her drawings, and she began feeling that maybe she wasn't as good as everyone had said. But finally, apparently satisfied with her

32

drawings, yet giving no word of praise or acceptance, he decided she had spent enough time on that lesson. He lectured her on the importance of a sculptor knowing the structure of the human skull, and her next lesson was drawing a skull. She had an idea by then of what would please him, and she began destroying her own drawings when she recognized their inferiority, before he saw them, and beginning anew.

In the evenings when the work was done and the studio closed for the night, Waldine enjoyed quiet conversations with Mrs. Coppini, who offered a comfortable refuge from the tensions of her studies and words of encouragement when things looked bleak.

"You must be patient, child, and understand that Mr. Coppini has many things on his mind. He doesn't mean to be short with you, but he is accustomed to dealing with men, not sensitive young girls. He is proud of you, I'm sure," Mrs. Coppini confided to her. Waldine considered her a substitute mother and loved her as such, not feeling any breach of loyalty to her own mother. Mrs. Coppini returned the love and accepted her new role with delight and dignity.

Active in the civic and social life of San Antonio, the Coppinis included among their friends many prominent citizens such as Mayor Bryan Callaghan and Harry Hertzberg, the jewelry millionaire. They often held large parties on the weekends and the guest lists impressed Waldine, as did the musical entertainment by famous opera singers, pianists, and violinists. The hard, calloused fingertips of violinist Maude Powell made Waldine realize that artists in all fields had to sacrifice something to their chosen art. Meeting so many famous people excited Waldine, and the aura of their success fanned the fires of her own determination to join their ranks. Social invitations sent to the Coppinis often included her, and on those occasions she felt more at ease and comfortable with Mr. Coppini. Away from the studio he seemed more pleased with her, and she even detected a note of pride in his voice when he introduced her as his student. However, in the studio she still dreaded his criticism when he disapproved of her work, often feeling inadequate and humiliated. Mrs. Coppini explained that his Italian ancestry was responsible for his being

Mrs. Coppini and Waldine enjoy a quiet conversation.

so temperamental and egotistical, but even so, many nights she cried into her pillow from his verbal abuses.

She often watched him as he worked on his huge creations, marveling at his speed and adeptness. Someday, she thought to herself, she would create such marvelous, huge statues, but when she mentioned her dream to him, he only laughed.

"Oh, no, not you. You dream too big. You stay with the busts and smaller works; they're your size. Large works like this take a man's strength to build such armatures and carry heavy loads of clay up the tall ladders. It's too strenuous for a woman."

Anger and indignation seethed within her and almost surfaced in protest, but she checked it in time and kept silent, while inside she felt her stomach churn in fury at realizing he had no intention of allowing her to even attempt large works. We'll see about that, she thought, vowing to herself that she would change his mind, in time. Women, she knew, were not always the delicate creatures men thought them to be.

Eventually Waldine drew only in the mornings, spending her afternoons studying the anatomy of the human body. She learned to be a plumber, screwing together different lengths of pipe to make the skeletal form of a statue; to be a carpenter, nailing scraps of wood to the skeleton to form the muscle structure; to be an architectural engineer, piling on mounds of heavy wet clay in such a manner that the weight would not cause the structure to capsize or tumble over; and, finally, to be an artist, creating the nude form into a thing of grace and beauty.

She studied for nearly six months, settled into her routine, became accustomed to hard work, and grew able to accept her teacher's harsh and often angry criticisms without feeling totally inadequate. She gave up her pursuit of praise without a sense of defeat, realizing that Coppini would not applaud her work even if he were satisfied, and she accepted his grunt of approval and lack of criticism as ultimate praise. Pleased with her progress, confident that in time Coppini would indeed make a fine sculptor of her, she no longer had doubts: her dream would be realized.

In that frame of mind and with a growing sense of accomplishment, Waldine saw her world quite suddenly and shockingly shattered. The Brady Tuesday Club wrote Mr. Coppini that they had no more money for Waldine's studies. She would have to leave the Coppinis and return to Brady. She had no idea the money would run out so soon; she thought surely she would be able to study for a couple of years. Broken-hearted, she cried like a child, without shame for her tears, and Mrs. Coppini tried to console her, but that was difficult for she herself felt like crying. Waldine was like a daughter to her, and now she would lose her.

"Well, it's just as well," Coppini said. "I'm so busy with my own work I don't have time to teach. Besides, you've learned enough to be successful. Just keep working and studying."

His words were not reassuring to her, even though she knew he meant them to be. She thought regretfully of the monumental works she had never had a chance to begin and now probably never would. She hadn't shown him after all, she brooded. But there was no choice. She had to go.

V

BATTLE OF LOVE

THE TRAIN to Brady chugged noisily across the gentle, sloping hills and past steeper hillsides quilted in the bright greens of mesquites and the reds and yellows of oaks changing their clothes for winter. Her departure probably relieved Coppini, Waldine thought ruefully, remembering that he had never wanted her to come, that he sometimes seemed perturbed by her presence, as if she were a nuisance and a bother, wasting his valuable time. Well, maybe I was an inconvenience, but he could have been less nonchalant about my leaving so soon, she reflected. She thought warmly of Mrs. Coppini, recalling how often the lady had taken her to her breast in comfort, acting as a buffer when tensions mounted, as they did so often. She would miss Mrs. Coppini dearly, and she found her tears could not be blinked away. She dabbed discreetly with her handkerchief, hoping no one on the train noticed. She felt drained and empty as she looked impassively out the window, and not even the serene beauty of the countryside consoled her sinking spirits.

As the train pulled up slowly at the Brady depot, she saw from the window her family and a throng of friends, including Mrs. F. W. Henderson and other women from the Tuesday Club, waiting to greet her. She was about to run into their

arms crying, when she noticed their faces beaming with happiness. She knew they were actually glad she was coming home and suddenly realized they saw nothing unfortunate about her return. She made an effort to be cheerful and hoped they wouldn't see the disappointment she felt in her heart.

Later that day, at the urging of her family and friends, she unloaded one of her trunks which contained the many small works she had done in San Antonio. Carefully lifting each one from its protective wads of newspaper, she heard exclamations of surprise and praise. Her audience noted enthusiastically her marked improvement, and as Waldine glanced around the living room at her old sculptures, she knew she had progressed much further than she had thought. But even as she recognized her own accomplishments, she cringed at her friends' satisfaction, for she was not satisfied at all. Tears welled up in her eyes and she turned her head to hide her sadness. Her friends must not know how utterly defeated she felt. After all, she admonished herself, through their efforts they paid for the exciting half-year she had spent with a professional, and her work was much better than before she left. Better, she thought in anguish, but not professional, and how would she ever be able to create the gigantic monuments that made up her dreams? She knew she never would. Having watched Coppini, she perceived far greater heights to attain, for she recognized and admired his greatness and knew in her heart that through his teachings she could also become great. It was that certain knowledge that allowed her to persevere in the hard work, frustrations, and humiliation; but without the instructions and driving force of her dynamic teacher, she felt her plight was hopeless, her dream of success futile, and her life barren.

Waldine modeled with clay Coppini had given her as a going-away gift, but with little hope for success she approached her work in a state of melancholy indifference. As she worked she became vaguely aware of a difference in attitude between her and her father. She felt that the close bond with her father, who had planted the seed of creativity in her mind, nurtured it, and encouraged it to grow, had somehow weakened in her absence. He seemed distant and uncommunicative, and she worried about him and about their relationship, puzzling over

the change but unable to pinpoint the cause. Had something happened to him while she was gone, she wondered, or was she the one who had changed? Had the stimulation of her exposure to professional artists made him appear less in her eyes? She didn't think so but couldn't be sure. Or had her success, however small, made him feel inadequate in his own eyes, contrasting too vividly and painfully with his own failures? She pondered the questions, searching for answers, and sometimes assuaging her mental torment by thinking the problem was only her imagination, for she could not think of any particular actions to confirm her worries. But the feeling was there, mystic and elusive, convincing her that something was stretching the gulf between them, and she grieved to think that perhaps they never again would be close. However, he at least appreciated her love of beauty and understood her burning desire to create it with her hands.

Her mother, on the other hand, still did not understand and had different plans for her daughter's life, which Waldine found unbearably exasperating and discouraging, especially since she could offer no proof that her art was indeed more important than seeking a husband. And there were many times when she wondered herself if perhaps her mother was right. Was her art merely a nice hobby? Was that all it ever would be? Her spirit cried in despair while she yearned passionately for someone with whom she could talk about art; but there was no one, not even an art teacher in the public school nor an artist of any kind in Brady.

While Waldine despaired of her misfortunes, the women of the Tuesday Club eagerly made plans for her first exhibit in the home of Mrs. Joe White, an important society woman whose husband was a Texas rancher. All the prominent people in Brady received personal invitations, and a newspaper item invited the public, yet Waldine could not muster any enthusiasm. On the day of the exhibit she dressed reluctantly but obediently, and as she left with her mother and sister she tried to respond to their exuberance, admonishing herself for her ungratefulness.

Her exhibit consisted of all the charcoal drawings, bas-reliefs, and anatomical sculptures she had made for study

purposes while in San Antonio. Everyone who attended lauded her with compliments, and those people meeting her for the first time appeared genuinely honored. Waldine found their enthusiasm contagious and was exhilarated when she left the exhibit at the end of the afternoon, feeling quite like a celebrity. She became more interested in the other exhibits being planned for her by Mrs. F. W. Henderson and Mrs. W. N. White. Yet, at the back of her mind continued the nagging thought that even though Brady considered her great, she would never become really successful, her dream could never come true, while living in a small town with no artist under which to study and improve.

The only contact she had with the art world was the occasional letters from Mr. and Mrs. Coppini, which, even though they thrilled her, tended only to increase her despondency. Mr. Coppini's letters were filled with news of commissions he was receiving for heroic monuments, and he often enclosed photographs of new sketches, bestowing upon her the honor of asking for her approval. Of course, she realized he fully expected only her praise, so she dutifully yet sincerely gave it. While he complained of how terribly busy he was, she reflected upon her own lack of direction and longed to be part of the exciting Coppini household again, even if it meant being busy to the point of utter exhaustion and constantly feeling humbled. She missed Coppini and his constant drive for perfection; she missed the parties with artists and musicians; and, as much as anything, she missed Mrs. Coppini's support and encouragement. She was home, yet homesick for another home.

Not wanting to depress the Coppinis, she always tried to write cheerfully, but the Coppinis knew her well and read the sadness in her letters. She had been in Brady only a few months when Coppini wrote:

Dear Waldine,

We have been missing you especially Mrs. Coppini. We have been thinking the best for all of us would be for you to come back and be my protégée, at no cost to you. You will live here as you did before and since I'm away

40

so much it would be wonderful for Lizzie, for she loves you so much.

Let us know by telegram and you can have your room as you had before. I know it will make Lizzie very happy. I will be leaving for Mexico City and would like to have you here before I leave. Let us know immediately.

Pompeo Coppini

She was thrilled about her unexpected good fortune, for she truly believed he could make her a great sculptor and that was her dream, her determination. She could not even speak coherently to her family of the news, but instead showed them the letter. There may have been objections from her mother, but she could not hear them over her own excitement. She knew she wouldn't have time now for a husband, and she didn't want to be tied down to anyone who didn't understand her passion for art. Besides, Waldine knew even her mother would approve, once she was successful, and now she knew she would be. She sent the telegram that very day.

Less than two weeks after she received Mr. Coppini's letter, she packed and again boarded the train to San Antonio. This time none of the beauty of the Texas hill country escaped her, even though the brilliant fall colors were gone and the trees, all except for the cedars, stood naked waiting for their spring dressing.

While Waldine was home Mrs. Coppini had learned to drive, and now she proudly met Waldine at the right depot in the car. The two were both wet-eyed with happiness as they drove to Madeline Terrace.

The next morning the Coppini household buzzed with activity. Coppini attended to many details before his trip to Mexico City, one of which was giving Waldine several projects to complete in his absence in addition to the chores she would be doing for him in the studio. His several works in progress would have to be sprinkled with water several times a day to prevent them from cracking, then wrapped securely with huge oil cloths that were hung from the ceiling. If the statues dried out, the cracked clay would crumble and all of his work would be completely ruined. She did not take lightly the enormous responsibility of caring for his statues.

There would be no gala parties until Coppini's return, but it didn't matter; Waldine was content to be back. She kept busy during the day, trying to complete her assignments to a degree of perfection that would please and surprise Coppini when he returned and stopping every so often to sprinkle his statues, so fearful that she would neglect them that often she spent more time than necessary wetting and wrapping them.

In the evenings, after she closed the studio, she and "Mother" Coppini, as she was to be called, relaxed over their supper and chatted enthusiastically about Coppini's prospects of commissions from Mexico, about her own work, and about the parties they planned for his return. Often friends invited them to their homes, and occasionally they invited ladies in for a card party or for afternoon tea, and there were always club meetings to attend. Waldine felt comfortable with Mother Coppini and just as much at ease with her friends, even though many were prominent citizens in the city and some were quite wealthy.

When Mr. Coppini returned from Mexico City with good news, high spirits and a hectic but exhilarating social life began anew. Waldine blended well, so well that many newly acquired friends and guests presumed she was the Coppinis' daughter. Often the Coppinis ignored the implication, acting as if that would make it true, would make her their daughter, for they both loved her as such. When confronted, they explained briefly that she was their foster daughter, not feeling that was exactly a lie, and Waldine felt flattered by her new status, never dreaming of the complications the false assumption would cause her.

She was delighted to have Coppini back, especially since he was so elated about the commission he received for an heroic-sized figure of George Washington for Mexico City that he was not even critical of her work. Instead he asked for her opinions, suggestions, and approvals, and she never felt more like an artist. She gloried as much in his acceptance of her as an artist as she did in being considered a member of the family, and marvelled at the fullness of her life.

She felt proud that he had asked her to return but was totally unprepared for what faced her. Coppini intended to maintain his well-earned reputation for speed and began his day

early in the morning, working until very late every night except Sunday, with only occasional short breaks for meals. He had the strength of a fighter and the determination of a mule, and a devoted assistant who never complained. She spent most of her day carrying heavy buckets of clay up the ladders to the scaffolding which encircled his work and upon which he stood, and then she climbed down again to gather up the globs of clay which had fallen or been discarded. She worked fast to keep up with her teacher, but even so, he occasionally waited impatiently for more clay, unaware of her exhaustion. Her shoulders burned like fire from the pulling weight of the clay, and often she feared she couldn't continue the gruelling pace, but she proved as stubborn as he and refused to admit defeat. She said nothing to Mother Coppini lest the kindly woman sympathize and intervene on her behalf, for she knew that Coppini would then look upon her not as his able assistant but as a mere woman without sufficient strength. She knew she had to prove her strength to him if she were ever to do monumental works, and so she trudged wearily on.

When Coppini completed each statue, he invited schoolchildren of all ages to view each work before it was cast into plaster. To Waldine's astonishment they came in busloads, and she was required to play hostess, showing them around the studio and describing in detail the various steps taken in the creation of a monumental statue.

After one such visit by a girls' school, Coppini discovered in alarm that many of his small tools were missing. Had the young girls repaid his hospitality by actually stealing from him? The terrible deed mortified Waldine, for she felt responsible and afraid Coppini's anger was directed more at her neglect than the children's theft. Would he ever trust her again, she worried as she telephoned the school, hoping she could remedy the situation. After a brief investigation, several of the girls admitted they wanted a souvenir of the famous sculptor and indeed took the missing tools. They hadn't meant to be thieves and, ashamed of what they had done, returned the tools immediately with profuse apologies. Coppini harbored no bad feelings toward them and in fact felt honored by the intent of the theft. Thereafter, however, Waldine watched the

visiting students much closer and before they arrived put up all the small tools.

After all who were interested viewed the clay statue, a caster came to the studio to make the plaster of paris mold. As the first step in the casting process, he inserted thin metal shims into the sides of the statue. Those shims would later allow him to break apart the hardened plaster into two pieces. He then applied a first coat of plaster, which he colored blue by putting bluing into the water before he mixed the plaster. Later, when he began chipping at the plaster and reached the blue, he would know he was getting close to the original clay.

When the coat of blue plaster hardened, he reinforced it with pipes bent around the statue both vertically and horizontally and also with fiber dipped into plaster. Then he put on the second coat, which was white. He then applied the third and final coat of plaster a full inch thick.

The hard plaster was carefully cut off the metal shims and separated, tugging and pulling at the clay beneath, until the statue pulled completely apart. The caster pulled the large pieces of armature and globs of clay out of the plaster. It was then Waldine's job to remove the clay from the armature, clean the bits of plaster from it, shape it into ten-pound blocks, and store it in the clay bin. The bin was actually a small room with an airtight door similar to that of a refrigerator. The used clay was kept wet so it would not harden and crack and would be used again on another statue.

With all the clay out of the mold, the caster cleaned it thoroughly and coated the mold with a green soap especially made for this purpose, making the inside of the mold slick and slippery. He filled half the section of the mold with plaster of paris, added pipes and fiber for strength, let it harden, placed the other half up against the first and filled it with about an inch of plaster. When all was filled in this slow manner and hardened, he removed the first pipes that wrapped around the mold and began chipping off the mold, being very careful when he reached the blue plaster. When he chipped through a few pieces of the blue plaster the soap-lined mold easily slipped off. When all the plaster mold was removed, Coppini touched up the seams, and the plaster statue was ready to be crated and

shipped to a bronze foundry in either New York or Italy, depending upon competitive price bids and deadlines. At the foundry their casters would go through a similar, yet different, process to create the statue in bronze. The original plaster statue would be returned to the artist, its owner, and the bronze shipped to wherever it would be erected.

The studio soon cleared of Coppini's statues, and as he began the armature for his George Washington, Waldine gratefully returned to her studies. She modeled heads and busts of friends who offered to pose, and although the person sitting praised her work, if Coppini found any flaw he made her not merely correct the fault, but tear apart the entire work and start from the beginning.

"Oh, no!" objected the person posing. "Let her just work on the nose a bit longer if it's not right. She'll get it right. Everything else is perfect."

"No, no! Tear it apart. It's no good. She must learn to do it right the first time," he responded impatiently.

Waldine twitched her mouth nervously and shrank in embarrassment at being upbraided in the presence of another person, but she knew the futility of arguing with him, and she never dared question his commands, so she obediently yet hesitatingly moved her hands over the cool clay, pushing the nose into the cheek and working the face into non-existence, feeling that a part of her own soul was being obliterated at the same time.

She understood that tempers were common among the artistic, so she endured and easily forgave, wondering at times if her own lack of temper was an indication of a lack of talent. She hoped not.

Professor John N. Steinfeldt, a well-known pianist and music teacher, lived nearby with his family, and the Coppinis and Steinfeldts were very close friends. Their daughter, Cecile, was only two years younger than Waldine, and the girls, both loving art and music, developed a deep, lifelong friendship. Cecile often came to the studio for lessons in painting and a visit with her friend, but her true love was the piano and she spent many hours each day being instructed by her father, who, like Coppini, was a perfectionist in his field. The girls

easily sympathized with each other, while they were prideful of their respective teachers' mastery of art and music.

In 1911 the Tuesday Club secured Waldine's first public commission, a bas-relief in memory of Mrs. I. J. Rice, which was paid for and presented by the Twentieth Century Club and Mary Walker Edwards of Brownwood. The bas-relief, a sculpture in which the figures stand out only a little from a flat background, was a new technique for her, but she found Coppini's tough lessons equipped her well for the task, and he allowed her total freedom in creating and executing her own design, beneath which was quoted, "Though bodies cannot, Souls can penetrate." Her work was placed in the Brownwood Library, giving her her first tast of immortality.

When Coppini's distinguished visitors saw Waldine's works in his studio, they were impressed with her talent and, since they knew Coppini was already too busy, began giving her commissions for busts of those they wished to immortalize. One of the first commissions she received came from Joseph Emerson Smith, the editor of the *San Antonio Express,* for a bust of his wife, Dottie Bell Smith, who later moved to Colorado and became one of the first state congresswomen. There wasn't a large sum of money paid — the amount was almost meaningless in itself — but the fact that she was getting paid for what she had always done freely gave Waldine a new sense of worth. Moreover, it made her realize that her art was no mere hobby or frivolous pastime, and she sent some of her earnings to her family: proof at last that she was not wasting her time. Other commissions for busts followed, and she soon was nearly as busy as her teacher.

As an accomplished sculptor, Waldine was no longer sequestered in the small room off from the gallery but was allowed to work alongside Coppini in his studio. While she worked she often watched him on a ladder or atop scaffolds erected to reach the uppermost heights of his heroic-sized monuments, and she felt a twinge of jealousy, a hunger to tackle greater works. Coppini's statues towered too high above her own small works and provided too great a contrast, too constant a reminder that she had higher peaks to climb, new goals to achieve. But how could she convince him, she

pondered. She knew her five-foot height and slender frame were not very impressive; yet, she argued with herself, hadn't she proven her strength when she helped him by carrying all those buckets filled with heavy clay? What more could she do? She tried again to discuss her doing monumental works, but he only dismissed her with a laugh. Disappointed, but knowing she couldn't force him to discuss it or convince him then that she was serious, she wisely let the matter drop. He was stubborn, but so was she, and he hadn't heard the last of it yet, she promised herself.

Meanwhile, the Coppinis were growing fonder of Waldine, for she had proven to be an excellent companion for Mother Coppini, and Mr. Coppini respected her diligent work. Although she occasionally dated young men she met at the Coppinis' parties, she had shown no inclination to marry, and he was convinced that she would always place her art career above matters of the heart. Proud that he was giving her the education and opportunities he felt she deserved, he still wanted to do more for her. He discussed her often with his wife, and one day he decided what they could do. They would adopt her!

Without Waldine's knowledge, he wrote a letter to her parents, explaining to them his generous offer and the advantages she would have as his legally adopted daughter, especially the use of his name. Certain they would understand and, wanting the best for their daughter, naturally give him permission, he was shocked and angered at their indignant rebuttal. Waldine was *their* daughter, they wrote, and since they were both still living, they could see no reason why they should be asked to give up their parenthood. Furthermore, they asked suspiciously, why did he think a twenty-two-year-old woman needed to be adopted? Was her own name not good enough?

Waldine simultaneously received a letter from her parents telling her of Coppini's outrageous proposal. Hurt and insulted, they asked her if she now felt so far above them that she intended to disown them. She gasped as she read, astounded by Coppini's audacity, and ached for her parents' obvious pain and bewilderment, for she understood how

47

heartbroken they must be, thinking she had knowledge of his idea. Oh, how could Coppini be so thoughtless, she cried, realizing the dilemma in which he had placed her. On the one hand, she knew she must somehow mollify and assure her parents that she loved them more than ever and convince them she had no knowledge of the plan for adoption and no intention of disowning them or of changing her name. It pained her, knowing that this could stretch the gap already existing between her and her father. Although annoyed with Coppini for tactlessly hurting her family so deeply, she reminded herself that his love for her had prompted him and he had meant no harm. She knew she must accept his deed as complimentary, while at the same time make him understand why he should not pursue the matter any further. She felt herself drowning in a frustrating whirlpool of emotions, being pulled in so many different directions. She grieved intensely to know she was the cause of pain to the four people she loved most in the world.

Waldine appreciated Mother Coppini's efforts to ease the tensions, reminding herself that she must stop calling her that.

Shortly after the Tauchs denied Coppini's request for adoption, they decided to move to San Antonio on the premise of greater job opportunities in the city. Enraged, Coppini saw behind their excuses and considered their move an insult to his integrity. Did they really think they had to guard their daughter, he demanded to know. Apprehension filled Waldine, for she feared her loyalties would be constantly questioned and tested by her parents as well as by Coppini, but she knew that anything she might say to dissuade her family from moving would be misconstrued by them.

Facing the inevitable, she began looking for a house for her parents to rent — something not too expensive, for she knew they would have little money. The chore took her away from Coppini and his rage. Mother Coppini proved again to be understanding, driving her around town to help her find a suitable home. When they finally found one on the East side of town with six rooms, Mrs. Coppini immediately wrote and invited the Tauchs to stay with them while they awaited delivery of their household goods; an obvious attempt to apologize for the misunderstandings.

She waited nervously for her parents' arrival, dreading it yet wanting to get it over. Would there be an explosion, she wondered, as she paced the floor of her bedroom, remembering the time she had wanted her father to see the beauty of Madeline Terrace; how she wished now that he wouldn't come, for she was afraid its grandeur would inhibit him and increase his own self-doubts. She worried that her mother would not be content in the six-room house she rented after her experience at Madeline Terrace. But mostly she felt plagued with the fear of having her two sets of "parents" living under one roof, each vying for her affection, and the possible arguments which might erupt over the adoption request. She loved them all and didn't want to take sides or hurt any of them in any way.

The Tauchs arrived to a cordial welcome from both of the Coppinis, and as her parents received the greeting with equal grace, Waldine sighed cautiously. Later that evening she watched uneasily as Coppini took her father into the studio, for she saw the look of awe in her father's eyes and knew it was not an appreciation of beauty that he saw but a reminder that he was outclassed, and she wanted to cry out to him that it didn't matter. She noticed that her mother, too, looked as if she felt out of place in such a fine home, and Waldine reflected sadly on the contrast of her own feeling of ease and comfort within these walls.

She was relieved when her family moved into their own home, and as a concession she stayed with them for the first two weeks to help them get settled.

"Waldine, there's enough room here for you. Why don't you move in with us? You can go every day to Mr. Coppini's studio to work. You don't have to live there now that we are so close," her mother argued.

Waldine had expected such a plea but was nevertheless unprepared to reply. "I don't know, Mother. It would take a lot of time to travel back and forth," she responded meekly, knowing that Coppini would lose his temper at such an idea. She hoped she wouldn't be forced to ask him.

"Nonsense. You tell Mr. Coppini that you will live at home," her mother insisted.

The next day Waldine hesitatingly told Coppini of her family's request and, as she expected, he was outraged, considering it another personal insult to him and a thoughtless inconvenience to their daughter. He absolutely refused their request, perhaps finding solace in the fact that he did have some control over her life, even if she was not his daughter. He reversed their logic, countering that Waldine could visit *them* every day, if she liked, knowing, of course, that she would be too busy to do so, since the house was quite a distance from the studio and they often worked very late.

Waldine soon grew weary of the bickering and jealousies that continued between her family and Coppini and often thought of leaving them all, of simply vanishing, but she had no place to go, and she didn't really want to go. She gave up trying to reason with any of them and resolved instead to do only what she felt was right for her with no apologies, which was to live with the Coppinis so she could study and work, and to visit her family as often as she had time. Her own obstinacy proved greater than Coppini's or her parents', and eventually they all stopped trying to influence her. Coppini consoled himself that he was at least her foster father and she his foster daughter.

Waldine's family lived in the rented house for nearly eight months, but her mother didn't care for the neighborhood or the yard, which had no garden for her to grow flowers. She wanted a house of her own, one they could buy instead of rent, and Waldine knew she would hear no end to her mother's woes until she was happy and content in her own house. She discussed her family's predicament with the Coppinis and was surprised to learn that he owned a vacant house on Roosevelt Avenue which he needed to sell. He had been unable to rent it, and vagrants often broke in; more than once during the cold winter months they had started small fires. The house needed restoring, which her father, handy at repair work, could handle, and Coppini would sell it to them very cheaply. Waldine knew her family could not afford it, even at the lowered price, but did not mention that to Coppini, for she planned to help them pay for it with money she was now earning.

The house thrilled Mrs. Tauch, for it was much finer than she expected, and she delighted in her new status as homeowner. Waldine visited her family more often, since the new house was much nearer to Madeline Terrace, and the feuding between the families subsided almost to the point of friendship.

Waldine, content with the improved relationships, relaxed and concentrated on her work, creating busts of well-known or wealthy citizens and earning a small, but respectable, income. Although pleased with the commissions she received, she still yearned to create a masterful work and frequently made subtle remarks to that effect to Coppini. She persisted even though she often felt her efforts were in vain, that he didn't even hear her pleas. But he listened more than she knew.

In early 1914, as part of a project to widen Commerce Street, the *San Antonio Express,* at Coppini's suggestion, commissioned Waldine to design and create a drinking fountain for the bridge which crossed the San Antonio River. The newspaper agreed to pay her one thousand dollars, and it seemed a fortune to her, but her biggest thrill was being entrusted with the actual designing.

The thrill, however, soon wore off as she faced the responsibility not only to the newspaper that paid her so generously but also to herself, for she knew whatever she created must uphold and enhance her growing reputation. She knew her career depended upon her first public monument. If she succeeded in pleasing the public, her career would advance and she would be nearer her goal of creating heroic-sized monuments. She shuddered, knowing that on the other hand, if she failed to please, she might spend the rest of her life doing nothing but small works, those expected of a woman. With determination and a huge reserve of imagination, she began her drawings, searching for the right idea, a true memorial. She spent several days making quick drawings, discarding them as trite, and starting over again. Finally one of her drawings felt right to her and she knew it was appropriate.

Her monument, done in high-relief, which is much less flat than low bas-relief, was an Indian in full headdress, standing seven feet tall (not an heroic size, but she felt she was

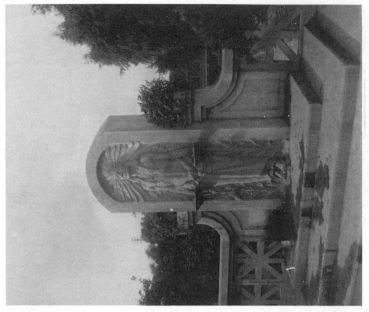

"First Inhabitant," 1914, was Waldine's first public work in San Antonio; it is on the Commerce Street bridge over the San Antonio River. This photo was taken soon after the statue's unveiling.

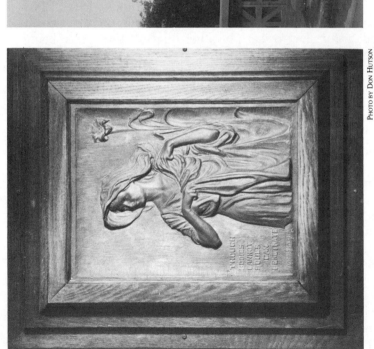

PHOTO BY DON HUTSON

"Mrs. I. J. Rice Memorial," 1911, bas-relief in the Public Library of Brownwood, Texas. This was Waldine's first commission.

52

getting closer). He appeared to be stepping forth from a spring, each of his outstretched hands holding an Indian-patterned bowl which concealed drinking fountains. She called her work the "First Inhabitant."

Before actually beginning her work, she spent many diligent hours at the library reading about the various Indians who inhabited San Antonio in its earliest days and studying pictures of those early settlers. She was amused to learn that the reason nearly all Indians were pigeon-toed was because they rode horses bareback, holding on with their toes. She searched for a full-blooded Indian to use as her model but, failing to find one, settled for a young man who was only part-Indian; however, his facial contours were correct, and even though he never rode horses bareback, he easily faked the pigeon-toes for her.

She hired Hannibal Pianta of San Antonio to cast her completed work in plaster and then in imitation stone, hiring yet another firm to erect her finished creation upon the bridge. When she paid her bills she discovered that the thousand dollars was indeed not the fortune she had thought it was, and little of the money remained for her. Yet the money held little consequence to her; it was merely a yardstick used by others to mark her success. She measured her success only by the special sense of immortality she felt in creating a monument that might last for hundreds of years and be seen by thousands of passersby, many who would only appreciate the cool drink it offered, but others who would appreciate her Indian for the work of art it was.

In June the newly formed Rotary Club, to which Coppini belonged, planned festivities to celebrate the Commerce Street project's completion and the unveiling of the "First Inhabitant," which highlighted the event. Waldine became the celebrity of the day and reveled in the spotlight, discovering that the grand and glorious feeling of accomplishment, recognition, and fame was everything she dreamed it would be. She saw the glow in Coppini's face and realized that he, as her teacher, shared her limelight; but she didn't mind, feeling that his pride in her was but another of her rewards, another accomplishment and perhaps one of the hardest achieved.

Coppini was not the only one sharing her glory that day, she noticed, as she saw her parents sitting tall and straight, with an affectation of dignity surrounding them, and she was sure that her success meant not only the beginning of her career but the end of arguments about her decision to be a sculptor instead of a housewife.

The following month, on July 28, Austria declared war on Serbia, planting the seed that would grow into the First World War. The United States did not at first enter the war, but tensions and uncertainties trembled throughout the country nonetheless. Jobs became hard to get, and although Waldine's father agreed to do any kind of construction work, building slowed down and it became difficult for him to find even that. Coppini also suffered financially, since governments have no money to spend on memorials to the past when defense budgets rise for the future. Individuals, wary of spending money, waited anxiously for the war to end.

Coppini had anticipated securing a lot of work in connection with the proposed Fine Arts Museum in Mexico City, but those hopes were dashed with the Mexican Revolution and the fall of President Porfirio Diaz in 1911. Coppini spent money and time making elaborate sketches of proposed monuments, only to discover that money could not be raised to complete a project. Falling deeper into debt with no promise of getting commissions in Texas, in 1916 he sold his beloved home in Madeline Terrace and moved to Chicago, where he hoped to find greater opportunities.

Waldine obtained small commissions, and since she had little indebtedness, she earned a sparse but adequate income. No longer a child, having reached her twenty-fourth birthday, and no longer a novice, having received a public commission and many private ones, she felt assured her career could continue and survive even without Coppini. She would surely miss them both, but she knew there would be frequent visits, and perhaps when the war ended, as it surely must, they would return. She wished them farewell on August 15, 1916, hoping he could find success in his new home. But the fears and uncertainties of war were paramount in her mind.

54

VI

SACRIFICE OF WAR

WALDINE MOVED in with her family after the Coppinis sold Madeline Terrace, using one of the large rooms for her studio. Her commissions for busts kept her sufficiently busy and enabled her to give her family some financial assistance. The arrangement, however, did not entirely satisfy Waldine, as there were too many distractions in the Tauch household making it difficult for her to concentrate. She wanted to have her studio elsewhere and found space she could afford in the Stevens Building on Commerce Street.

Besides her work, she attended parties and club activities, constantly promoting artistic interests and at the same time seeking new commissions. At a club social she met a young man she found especially appealing and interesting. Her zealous ambition and determination fascinated and intrigued him, and he began escorting her about town. She enjoyed his companionship and eagerly awaited the evenings when he came to fetch her. For her, the concerts they attended together sounded more melodious, the dinners they shared tasted more delicious, and the world around her looked more rose colored, even though the war persisted threateningly across the sea. She soon realized that she was actually falling in love and understood why it had always been easy to resist the temptation of marriage,

why she considered her art more important than love. She had simply never experienced the blinding, bewildering ecstasy of love before then.

Yet, although she wanted their relationship to continue and could not imagine life without him, thoughts of marriage frightened her. She thought of her father and how certain she was that he could have succeeded as a photographer if he had remained single, without the burden of a family. But mostly she thought of her foster father and her promise to him that she would never marry. She remembered she hadn't exactly promised in her declaration to him but knew that he had always considered it an absolute oath, and she feared his certain wrath if she should decide to marry. Even in her most romantic thoughts, her career and Coppini's approval remained more important to her than anything else, even love.

Meanwhile, Europe remained stubbornly at war and rumors abounded that the United States might become involved. Waldine feared that the man she loved would be drafted, and she couldn't bear the thought that they might be separated. The fear of war worried everyone, and money became even tighter. She herself had great difficulty getting new commissions, even small ones, and times grew harder. However, in March of 1917 a stroke of good fortune came her way when Gus Noyes, a rancher from Menard County who had known her as a child when she lived on her uncle's ranch, wrote to her. His son, Charles, had recently died after a fall from his horse, and after reading of her works in the *San Antonio Express,* he wanted her to make an equestrian monument in his son's memory. She felt honored by the man's faith in her to do such an important monument, and she knew her family sorely needed the money. For herself, the commission offered a challenge which sent her nerves tingling in excitement, since the statue would be larger than life-size. Even her "First Inhabitant" had not been that large, and being high-relief, it was not a true statue.

But as the initial excitement wore off, she grasped the gravity of accepting such a responsibility, worrying that perhaps she was rushing headstrong into something for which she was not quite ready. Mr. Noyes, already beset with grief

over the loss of his son, should certainly not have to face another disappointment, she decided, doubting her own ability. Yet she wanted the commission; she hungered desperately for the chance to try. But after doing much soul-searching, despite her own yearnings and her family's financial struggle, she recommended Coppini for the work. With regrets, some doubts, and a sorrowful sense of loss, she convinced Mr. Noyes to contact Coppini, even promising to write the letter herself. When he finally agreed, she found herself tremendously relieved and knew she had done right, even though her family was keenly disappointed.

Coppini, however, saw different reasons for her refusal when he received her letter, stating to his wife, "She turned down the job in order that it might come to me, to express her appreciation for what I have taught her." He felt good about his foster daughter's devotion.

His reluctance to return to Texas, however, surprised Waldine; but after he discussed the monument with Mr. Noyes he changed his mind and was grateful to her, for the man was willing to pay quite well. Coppini and Waldine enjoyed a brief visit before he returned to Chicago to begin his sketch, actually a miniature statue, as a sculptor's sketch is not a drawing, but a detailed model.

The next month, on the sixteenth of April, 1917, the news everyone expected and dreaded came: the United States officially entered the war. Shortly after the announcement, Waldine's young man, along with thousands of others, received his letter of "congratulations" and his orders to leave immediately for basic training in Virginia. Many young couples in the same situation quickly married, as if there would be no tomorrow. The moment Waldine feared arrived, when he too proposed marriage, but she stalled, asking him to wait until the war's end. She hoped that would give her time to think her life through and know her mind.

She accompanied him to the train station when it was time for him to leave, and as they embraced he begged her again to marry him. Her heart ached to say yes, to go with him, to be near him, and bitter tears ran down her cheeks as she again refused. As the train pulled out, she waved to him, wondering

if she had been foolish, worried that she might never see him again. But she had made her decision.

She resumed her sculpting, but without much zest, and her days dragged slowly by, now that she would not see her young man in the evening. Often, to keep her mind off her loneliness and empty evenings, she worked in her studio until late at night. But then, as she completed her commissions and received pitifully few new ones, she found little to keep her busy.

Meanwhile, the women's clubs in San Antonio worked for the war effort, among other projects giving many parties to entertain soldiers at the several military bases and also in the courtyard of the Alamo. The clubs provided the refreshments and music, as well as matrons to serve as chaperones. Since many of the clubwomen knew Coppini's protégée, they soon recruited her to help serve refreshments, and she was glad, since the activity helped fill the otherwise lonely evenings.

Nearly a year later, on July 2, 1918, the *Chicago Tribune* announced plans to commission sculptors to work jointly in creating a magnificent memorial for the war heroes. Coppini enthusiastically wrote Waldine, urging her to come to Chicago at once. Since San Antonio offered little work, she decided to do just as he suggested, eager for an opportunity for a good commission and for a chance to be with the Coppinis again.

When she arrived in Chicago, the Coppinis were living in a beautiful, four-story mansion on Grand Boulevard, which at that time was in an elegant neighborhood in Chicago. She wondered why *he* complained of hard times, for he seemed to be doing quite well for himself.

While she and Coppini awaited further information on the elaborate war heroes memorial, he completed his sketch for the Noyes Equestrian, and invited the Noyes family to come to Chicago to inspect it. They came and gave their immediate approval. Waldine took the family on tours of the city, and a party was held in their honor before their departure.

When the City and the Parks Department announced that they could not, after all, afford the magnificent monument they had earlier proposed, the many hopeful sculptors felt a terrible blow had been dealt them. For many, sculpting was their only

livelihood and they were growing very hungry. But monuments are built in times of peace and affluence by a citizenry eager to spend money to honor those who died on the battlefield, perhaps in an attempt to alleviate their own guilt for survival. In times of war no one knows if he will be amongst the survivors, if the war will be a victory or a defeat, if it will be worth remembering or better forgotten. Everything — money and effort — is spent on survival. Nothing remains for monuments, and those who create them suffer.

Coppini and Waldine were more fortunate than many. He had the Noyes Equestrian and a commission for the Sul Ross for Texas A&M University in College Station; ironically, both commissions came from Texas. She gained the distinction of being the first woman to design and create a war memorial when she won the commission for the "Indiana War Memorial" for Bedford, Indiana, competing against many other hungry sculptors from different parts of the country. She went about the studio humming and smiling, delightedly amused by Coppini's grumblings because her monument was to be heroic in size, and he still did not think a woman should handle such a feat. She gloated happily to herself that she had shown him after all, despite all the discouragement he had given her.

The main figure of her statue, "Indiana," was fourteen feet tall, with panels on each of the four sides of the base measuring six by nine feet. When she completed her clay model, stonecutting machines cut her statue into Bedford limestone, which was then prominently placed in front of the Lawrence County Courthouse.

She thought of her boyfriend often, although her terrible yearning had been subdued by all the excitement and activity she found in Chicago and at the Coppinis'. She wrote to him with dedicated regularity, careful to skirt the issue of marriage, for she still could not decide what to do, afraid that her choice would determine the fate of her hard-earned career. When he wrote that he would be in San Antonio on leave, she had to go to him, despite Coppini's obvious disdain of her involvement and his stern reminders that her career must always come first, that she should stay to work on her commissions. "Let him

AUGUSTANA UNIVERSITY COLLEGE
LIBRARY

come here," he demanded, but she knew he couldn't, nor did she want him to come, realizing that Coppini would allow them no privacy, and she didn't want Coppini clouding her thoughts on marriage, as he surely would try to do. She wanted the decision to be hers alone.

She began packing for her trip, wondering absently if she would ever return. Would she marry and be able to surrender her career, or would she have to? Couldn't she marry and just as easily continue sculpting, with a loving and understanding husband by her side for support? She thought of the few married women she knew who also had careers, but she wasn't quite convinced. However, Coppini had been wrong about women doing monumental works; perhaps he was wrong, too, about marriage. In the midst of her contemplations, a letter arrived from her mother, and Waldine's worries and anxieties took a different turn.

Mrs. Tauch had been told by one of her friends, the kind who derive their pleasure from inflicting misery on those around them, that Waldine was running around with a married man. Her mother had been shocked, horrified, and disbelieving, but she did some investigating on her own, she wrote, hoping to find that the woman had erred. Instead she discovered that Waldine's boyfriend was indeed married and, furthermore, had two young children.

At first the full impact of her mother's letter did not sink into Waldine's consciousness, but when she fully comprehended the contents she became so violently ill she took to her bed for several days. How could she have been so deceived, she anguished, as memories of their times together fluttered across her mind, not fondly as before, but mockingly, cruelly. She wanted so desperately to disbelieve what her mother wrote, but how could she? She remembered how delighted her mother had been at the prospect that her ambitious daughter might, after all, relent and marry. Her mother, of all people, had no reason to lie to her, and finally she admitted that her boyfriend had indeed made a sham of her love for him. She couldn't understand why he'd bothered to propose, wondered angrily what he'd have done if she'd said yes. She almost wished she had, just to see him squirm. Or was he so low, she wondered,

that he would have married her anyway? She gasped in sudden horror at the idea of being married to a bigamist.

"It is good you found this out," Coppini consoled, "for you could have ruined your whole life, everything you ever worked for. It is all for the best."

She mustered a weak smile, but inside she wanted to scream at him. Why couldn't anyone say "It's not true?" That would be the best, she thought. She knew Coppini was relieved that her affair was over, and she felt a terrible, unjustified anger toward him, yet she showed no anger, hiding it deeply along with the other hurts she hid so well.

Anger began to replace and heal her pain, and she decided to go to San Antonio and confront the man who had stolen her heart and callously torn it to shreds. Perhaps down deep within her she still hoped he could prove the rumors false.

As soon as she arrived in San Antonio, she arranged a meeting with him at her parents' home and paced the floor nervously as she waited for him to arrive. When he came, unsuspecting, he started to put his arms around her, but she gently pushed him away and told him bluntly what she had heard. He was about to protest when she silenced him, saying, "If it is true, then just turn around and leave. I never want to see you again."

He hesitated, obviously flustered, but as he was about to offer a meek apology, she ordered him out before he could say any more. As she watched him leave, she was surprised that she felt no emotion other than relief that the confrontation had not been as difficult as she had expected. The love she had feared she still felt for him was utterly destroyed, and her heart no longer ached for him. It had been easy to watch him go.

She remained in San Antonio for a short visit with her family, shrugging off their sympathy, for she felt in no need of pity, only an eagerness to return to Chicago and to her work. Her career was, she acknowledged, her first love, her own true love, and she needed nothing more. It felt good to have the confusion washed away.

The day Waldine boarded the train for Chicago was the eleventh of November, 1918, and as usual the cars held more young soldiers than civilians. Along with the other young

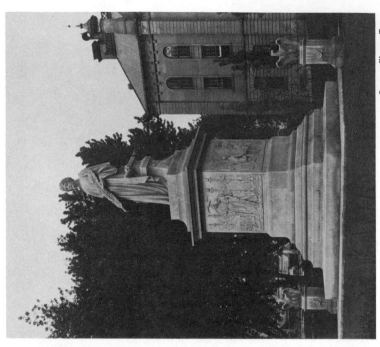

PHOTO BY WALDINE TAUCH

"INDIANA WAR MEMORIAL," 1926, IN FRONT OF THE LAWRENCE COUNTY COURTHOUSE, BEDFORD, INDIANA, IN MEMORY OF THE SOLDIERS, SAILORS, AND MARINES OF THE FIRST WORLD WAR.

PHOTO BY WALDINE TAUCH

"HENDERSON MEMORIAL," 1919, CREATED IN TRIBUTE TO MRS. F. W. HENDERSON, ONE OF THE WOMEN RESPONSIBLE FOR BEGINNING WALDINE'S CAREER.

62

women, she received more than her share of wolf whistles as she boarded and walked down the crowded aisle to her seat. Under the circumstances of war she showed no offense nor did she feel any; her contribution to the war, she thought wryly. She sat down next to a window and was soon joined by a young man in uniform. She studied his face with concern, seeing the gravity in his eyes that belonged to a much older man, and knew he had seen the war closely. He looked little older than a child, yet she knew he had lost his youth forever. She didn't attempt conversation, but instead looked out the window as the country sped past.

As the train journeyed through towns, she was puzzled to see dummies hanging from trees and bands playing triumphantly to cheering crowds. She broke the silence by asking her companion if he knew the reason for so many celebrations, but it seemed no one on the train understood the cause, and everyone began speculating, until one of the porters pranced into the car and practically danced down the aisle, shouting joyously above the din, "The war's over. We won! We won!"

Everyone, civilians and soldiers alike, began shouting and slapping each other good-naturedly on the back. Some cried in happiness; others shed their tears more quietly, since it was already too late for their loved ones. Waldine's companion took her by surprise when he hugged her and then kissed her on the cheek. She smiled brightly, seeing the miraculous change in the soldier, for his eyes once again twinkled with the promise of youth, of hope. The entire trip became one long party, and Waldine arrived in Chicago exhausted but in high spirits.

Soon after her return she received a letter from Mr. F. W. Henderson awarding her a commission to create a cemetery memorial to be placed over his wife's grave in Richmond, Kentucky. Waldine appreciated the chance to do something to repay the woman who had been largely responsible for placing her in Coppini's home as his student. She spent a great deal of time and thought in creating a sketch that would do justice to the generosity of Mrs. Henderson. She designed a life-size figure of a woman kneeling and praying, as if in grief for Mrs. Henderson's death.

Her minature sculptor's sketch for the Henderson memorial was accepted, and she began the armature for the full-sized figure, while Coppini worked on the Noyes Equestrian. As usual, they both had deadlines to meet, but once they completed their armatures and applied most of the clay, they felt they could relax.

Chicago was in the throes of winter, and every evening before they closed the studio Coppini carefully banked the fires in the large furnaces so the studio would stay warm through the night and the clay statues wouldn't freeze. Even on days when they did not plan to work, one of them drove to the studio to check the fires and add coal; however, the war had caused a severe coal shortage, so they were careful not to use too much.

One night while they slept soundly a severe blizzard struck quite unexpectedly, pouring snow down upon the sleeping city so swiftly that before anyone in the Coppini household awoke, there was already a five-foot high snowdrift piled up against the house. Coppini awoke first and frantically roused the women. Since they had not expected the freezing storm, he feared the fires they'd lit in the studio were insufficient, and he was determined to get through the storm to the studio six miles away. Mother Coppini tried desperately to dissuade him from going, but he stubbornly insisted, and Waldine volunteered to go with him, as worried as he about the nearly finished statues that would be ruined if they froze. Mrs. Coppini threw up her arms in exasperation, for she knew it was useless to argue with either of them once their minds were made up. Such hard heads, she thought as she trudged wearily into the kitchen to make them a thermos of coffee to take on their adventure, knowing that she would also stay up and wait for their return, no matter how long they took.

Coppini and Waldine put on many layers of clothes, for even the sound of the howling wind sent icy shivers up their backs. They would have to walk several blocks to the train depot and they weren't sure how far the train would carry them, how much farther they might have to walk.

"Waldine," he said, "you should stay here. It's too cold out there and the streets are already very bad."

"If you're going, I'm going. I have a statue there, too," she replied, thinking that again he was considering her a fragile woman. Would she ever win the battle, she wondered.

"Then let's go," he commanded, and they left the cozy warmth of the house. Outside, the wind fiercely hurled ice and snow into her bare face, piercing her skin like little knives, and the power of the gale nearly knocked her off her feet. She held onto Coppini's arm to regain her balance, then attempted to walk alongside him. They both had difficulty pushing their weight against the strength of the wind, which tried to knock them back and succeeded in slowing them down tremendously. Waldine's feet were in terrible pain from the cold, although she wore several pairs of heavy socks and boots over them, but she became more afraid when the pain began to go away; her feet were becoming numb and frostbitten. Breathing became more difficult and painful, and she felt the air freezing her lungs. When Coppini saw her distress he insisted that she return to the house and wait for him there, and frozen as she was, she welcomed his chivalry, no longer caring to prove her worth or be a martyr.

Coppini pushed stubbornly against what seemed to be a nearly solid wall of wind, reached the depot, and boarded the waiting train. But when he arrived at the studio, it was too late. The wet clay was already frozen, and nothing could be done to save their works. Ice which formed in the wet clay created a grotesque mosaic, and Coppini knew that when it thawed the clay would crumble to pieces. Ruined! He cursed the war that caused the coal shortage.

Hours after he had left the house, he returned, angry and defeated. Upon hearing the news, Waldine cried in bitterness, certain they couldn't meet their deadlines. Their reputations would be ruined and their commissions lost.

Mother Coppini listened to Waldine wail and moan and to Mr. Coppini curse and pace about in anger and frustration until she finally became disgusted with both of them and redressed them severely for acting like children. Mrs. Coppini had never raised her voice before then, and the two were startled at her sudden outbreak; however, she succeeded in calming their hysteria and made them realize that all their

fussing and fuming could not restore the lost statues. They would have to do that themselves, and they had no time to waste on remorse. The deadlines that had seemed so easy to meet were now almost impossible, but Mrs. Coppini filled them with a new determination, then sent them both off to bed.

The next day they began chipping off the ruined clay, which fell apart easily. They consoled each other that, at least, they would not have to rebuild their armatures. Having shared misery and disappointment, they now shared a positive attitude of success, and even when night fell and they continued working, although filled with the burning pain of tired, overworked muscles, they laughed together. Mrs. Coppini often carried hot suppers to them when they worked late into the night, knowing the two could easily forget to eat, so engrossed were they in finishing their works.

Two weeks later, after working fourteen hours a day, they finished what had taken months to do the first time.

"Not bad for an old man, eh?" boasted Coppini, who at 48 was in his prime.

"No, but not bad for a woman, either, *eh?*" she mocked, and they laughed together in their mutual pride and exhaustion.

The end of the war brought prosperity to the nation once again, especially to the sculptors who received lavish monument commissions. The war having been won, those who died in it would be remembered fondly.

When Coppini received the large commission for the Littlefield Memorial Fountain to be placed at the University of Texas in Austin, he found his studio too small for the gigantic figures. Since the bronze foundry was in New York, he felt that he could save a great deal of money by moving there, so Waldine packed her things and again returned to her home that December of 1922, while the Coppinis moved to New York City to find a home and studio.

AT THE TOP OF THE LADDER

VII

A GREATER DEPRESSION

MANY SUITORS entered Waldine's life, some with offers of marriage, but none tempted her to break her vow to Coppini. At thirty, she reasserted that marriage and an art career could not mix, at least not for a woman. Her dedication to classic art gained intensity in the postwar years through her increased commissions, contracts with other artists, and involvement with art societies, universities, and galleries.

In Chicago she joined with Coppini in his crusade to promote classical fine arts throughout the nation. Her return to San Antonio and separation from Coppini had no effect on her ambitions, for his influence and ideals were already so deeply imbedded in her that they were her own.

Her sister and brother had married and moved into homes of their own, so that when Waldine arrived it was not necessary to locate a studio away from her parents' home. Even before her crated works arrived from Chicago, she was awarded new commissions. In San Antonio's budding art culture, which during the war had become nearly dormant, she had developed many friendships, and she was anxious to get involved with them again.

The Art Guild, started before the war by local artists such as Rolla Taylor and José Arpa, had disbanded during the war

69

but was now reorganizing with Waldine in the hub of activity, pushing and shoving young artists into the limelight and into success. The Guild held private workshops for its members, exhibited their works in museums and galleries, and gave lectures to interested civic clubs and groups; but mainly it supported and encouraged those in its ranks struggling for recognition. Waldine insured that their labors were well publicized through her contacts with newspaper staff.

The vigor and zeal of the Guild members were contagious, and each member fed off the enthusiasm of the others, increasing his own momentum and productivity. Not having to work at another job, as many artists did, Waldine devoted all of her time to sculpting, setting up or taking down exhibits, speaking to various clubs about the Guild and about her and Coppini's work in Chicago, occasionally instructing young artists, and submitting press releases. Her passion for art and optimism for its progress gave her the necessary energies to work so hard for herself and for others. No longer a mere student or novice, she enjoyed her rank as a professional, always eager to share her knowledge and experience with young artists, and having a grand time of it all.

Meanwhile, in New York City, Coppini found and purchased an apartment building on 14th Street and proceeded to convert part of it into a studio while Mother Coppini decorated their new apartment in the same building. Waldine wrote to them constantly, telling them of the exciting activities in which she participated, and kept informed of their progress from Mrs. Coppini's letters. They were each pleased with their own individual progress and enthusiastic about their own lifestyles.

However, one morning during that summer of 1923, Waldine received a frantic telephone call from Mr. Coppini.

"Waldine, something terrible has happened. Lizzie fell off a ladder. Nothing broken but she's badly bruised, and the doctor says she'll have to stay in bed for weeks. I've got to be in the studio while the building is going on and I can't find a nurse. Could you please come and take care of her?"

She sighed quietly, thinking of the deadlines she had to meet, the engagements to lecture, and all the other commitments she had made to the Art Guild. She thought of the

expense of crating her unfinished works and shipping them to New York. The cost would cut deeply into her profits, profits she thought she might have to forfeit altogether if caring for Mother Coppini totally monopolized her time so that deadlines could not be met. But then she thought of Mother Coppini's suffering and realized that without their help she would have no commitments, no commissions which had deadlines and profits. She constantly recognized that fact and knew she could never refuse them any request, not only because of her gratitude, but because she loved them as much as she loved her own parents.

"Yes, of course, I'll come," she finally replied.

"Oh, thank God. She'll be so happy to know you're coming. I hated to ask you, but I didn't know what else to do. I've got so many deadlines I'm about to go crazy. And now this. It's just terrible."

"Well, now, don't worry about a thing," she added as cheerfully as she could. "I'll be there in just a few days and take care of everything. Give Mother Coppini my love."

She sighed as she replaced the receiver on its cradle, feeling none of the cheerfulness she had tried to convey to Coppini. There was such a lot to be done before she could leave. She had cheered him up somewhat, but she found herself as frantic as he had been. She hurriedly placed telephone calls cancelling her commitments and began the tedious task of crating her works to ship to New York.

She arrived in New York City hot and dirty after the long train trip, eager for a bath and bed. Mr. Coppini and one of his brothers-in-law were waiting at the station to meet her and to take her home by way of the city subway, a new and fascinating experience for her, like a train minus the scenery, she thought.

Mother Coppini's eyes lit up when she saw Waldine, but Waldine stood in horror at the sight of the older woman, for grotesquely colored splotches of blues, blacks, reds, and purples covered her face and, as she later discovered, one entire side of her body. After a moment's hesitation, she ran into Mrs. Coppini's open and waiting arms, being careful not to hurt her in the embrace.

Waldine spent nearly all of her time nursing her foster mother, keeping house, and cooking meals for the three of them, since there were no servants. She fretted silently about her commissions as week after week passed, wondering how she would ever meet her own deadlines and save her reputation. However, with Waldine's care, and perhaps because she realized Waldine's dilemma, Mrs. Coppini began recovering sooner than the doctor had predicted, and Waldine was able to spend some of her time in the studio, working faster than she had ever worked, making every minute count double to make up for the lost time.

When Mrs. Coppini recoverered sufficiently, the three of them spent Sundays exploring art museums, galleries, and exhibits, both private and public. Waldine marvelled at the tremendous amount of cultural activities occurring throughout the city, finding New York an absolute haven for artists of all kinds.

With the completion of the studio, Coppini began work on the gigantic armatures for the Littlefield Memorial Fountain, a $250,000 project for the University of Texas in Austin. Since the Chicago incident, when his and Waldine's statues froze and were ruined, they used a new substance called plastilina, an artificial clay developed in Italy which worked like regular clay but would not harden or freeze. Although more desirable, plastilina also cost considerably more: $700 per ton compared to $25 for clay. To compensate for the higher cost, they created their armatures so completely formed as to need only a very thin layer of plastilina; therefore, a lot more time and work was spent on the armature.

Coppini allowed Waldine to assist him, and they began building the first horse with a wood framework, applying wood laths cut into small pieces to keep the armature in perfect proportion. When they completed one of the wooden armatures, the anatomy of the horse was so precise that visitors to the studio insisted that Coppini display it as it was, since, they said, it looked more finished than most of the modern sculpture that blemished the city. He laughed in agreement, for it was indeed a work of art in itself, but he would never consider exhibiting an unfinished work.

Besides assisting Coppini, Waldine created small pieces and sold them to the Gorham Company, which had its own bronze foundry to cast them in quantity. She employed models for most of her sculptures, using both amateurs and professionals. For one such statuette, "The Boy and the Eel," which was 17" tall, she used the four-year-old son of the apartment building's janitor for her model. When she asked the child if he would pose, he agreed eagerly, thinking it would be quite fun, and he liked the idea of earning some spending money.

His older sister brought him to the studio and he climbed gingerly upon the platform where he would be posing.

"Now, take off your clothes," Waldine instructed.

The child showed no surprise or alarm and quickly slipped off his shoes and socks, and removed his shirt.

"Take off your trousers, too," she added when the boy had stopped undressing.

"No!" he cried out in alarm, and held firm to his pants and his refusal. He had not bargained for exposing his private parts, and no amount of prompting by his sister or Waldine could change his stance. Not until, that is, he was offered an ice cream cone in exchange for his trousers. Thereafter, each day when he came to pose Waldine had his ice cream cone ready, and he had no qualms about the trade. Her small work sold many bronze reproductions.

As the studio filled with finished works and others in progress, Coppini held open house on the first Sunday of every month, inviting as many as a hundred guests, including the several artists living in the building. Famous musicians and opera singers, many originally from San Antonio (such as Josephine Lucchese Caruso, Edith Giffen Noel, and Rafael Diaz, who was then a member of the Hammerstein Opera), performed at these events. Coppini, an active patron of the lively arts, often invited young musicians to entertain as well. Many members of New York's high society attended the functions, and the publicity and contacts benefited both Coppini and Waldine.

Meanwhile, in San Antonio the Scottish Rite was planning to build a three-million-dollar cathedral. Coppini, a high-degree Mason and member of the Scottish Rite, persuaded them to

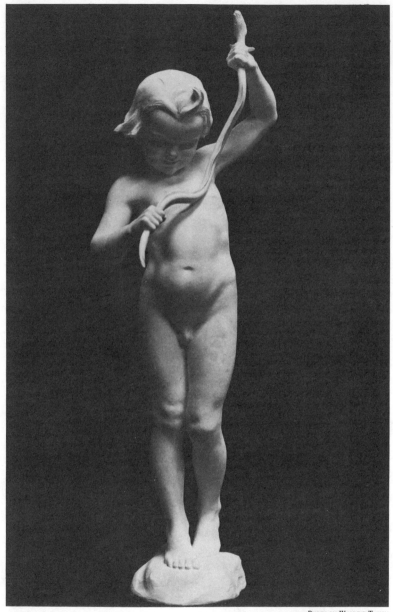

"BOY AND EEL," 1924, MADE IN NEW YORK AND CAST IN BRONZE BY THE GORHAM COMPANY. MANY REPRODUCTIONS HAVE BEEN SOLD.

commission him to carve two bronze allegorical doors for the front of the cathedral, depicting symbolically the different religions from ancient times to the present. Waldine spent nearly a year researching at the library for information on the various religions of the world for this project.

The studio became a hectic workplace with both sculptors working on several statues at a time in various stages of completion. The memories of the World War still provided many opportunities for commissions, and Waldine kept more than sufficiently busy with her own works, yet still found time to assist her master whenever he needed help.

The Women's Parliament Club in Temple, Texas, asked her to design a memorial to the soldiers of Bell County, and while in New York she created a small sketch which she carried with her on her annual Christmas trip to San Antonio. After the holidays she took the sketch to Temple to get the women's approval, and there the Lions Club invited her to speak. She lectured excitedly about the monument she wanted to create for the Bell County soldiers and about the need for a number of such monuments to mark historical spots and recall historical events in Texas history.

Her ideas of preserving history through art interested the Lions Club members so much that they requested her to create a bronze bust of Bell County's latest pride and joy, ''Ma'' Ferguson, recently elected to serve as Texas' first woman governor. Before Waldine left Temple she conferred with Governor Miriam Ferguson so that she could study the woman's face and take measurements of her head and shoulders.

However, on those two works Waldine never received a commission, perhaps because after her departure their initial excitement over the projects cooled, or perhaps the projects' costs proved too ambitious. Waldine tolerated their apathy with resignation, if not some indignation. She often spent a lot of her time on prospective commissions which never materialized, and she understood without much sympathy those who did not give art as important a place in their lives as she did.

Meanwhile, Arthur Hammerstein commissioned Coppini to create an heroic statue of his famous father, Oscar Ham-

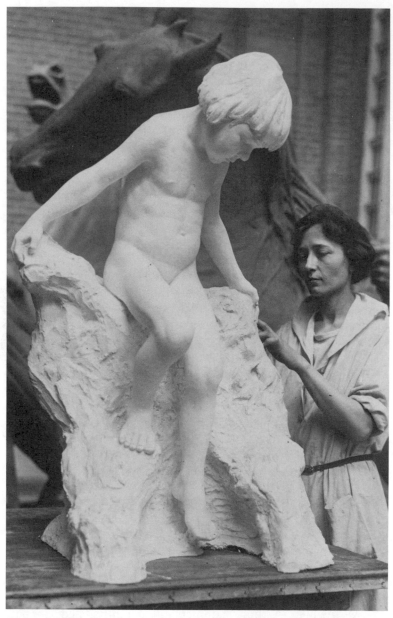

WALDINE WORKS ON "YOUTH REFLECTS," 1923, IN THE NEW YORK STUDIO. IN THE
BACKGROUND IS ONE OF COPPINI'S HORSES FOR THE LITTLEFIELD FOUNTAIN.

merstein, to be placed in the new Hammerstein Theater on Broadway, then under construction. However, Coppini was still working on the Littlefield Fountain and Memorial, which was so large it left little room in the studio for any other statues. The main pieces of the fountain needed to be completed immediately so they could be removed from the studio for casting, giving him and Waldine room enough to work on their other sculptures. He decided to hire a young man to build the armature of the huge female figure symbolizing "Columbia," but he soon discovered that all the sculptors — even the young ones — were too busy with their own works, and he could find no one.

"I'll do it!" Waldine announced firmly, seeing her teacher's dilemma, which was also hers, for she too needed more studio space.

"But it's too large for you," he remonstrated, still holding to the idea that heroic works should be left to the men.

"Nonsense! My Indiana monument was nearly as large," she said, "and you'll not find anyone else to help."

She was right, he knew, for he had already tried without success, and he found he had no choice since the works had to be finished and removed. Although he didn't like to admit it, he thought she could possibly handle the task.

As she began the armature, she knew he watched her, but she carefully prevented him from knowing that she noticed. She wanted to impress him with her strength and often went to bed utterly exhausted, her muscles burning in protest against the burden she placed upon them, but she felt that the importance of proving to Coppini that she was capable, even though she was a woman and even though she was small, far outweighed her physical agonies.

"I'll be damned if you don't work harder than any man I've ever seen," he admitted after a few weeks. "I don't believe there is anything you can't do."

She tightened the muscles of her lips to hide the smile that filled her soul, discovering his acceptance of her as his equal more important than the mere creation of the heroic work. She completed the armature in record time. Her body even seemed to stop complaining.

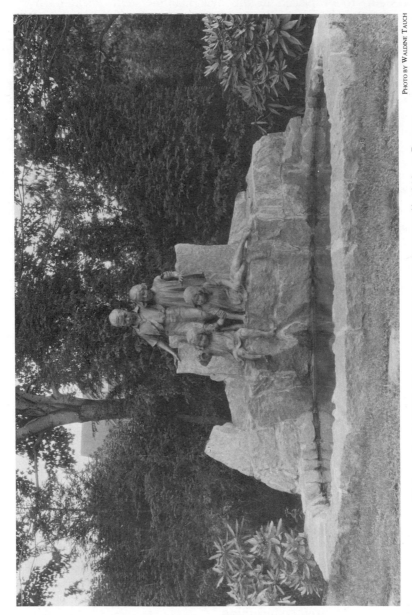

"LeSueur Smith Children Garden Portrait and Fountain," 1928, in Pelham Manor, New York.

78

In the early part of 1927 the Coppinis bought an expensive home in prestigious Pelham Manor, which gave them and Waldine the opportunity to entertain even more lavishly. They met many of their wealthy neighbors, and later that same year one of the them, LeSueur G. Smith, awarded Waldine a $10,000 commission for a garden portrait fountain of his four children.

The children, three girls and one boy, were brought to the studio one at a time by their mother to pose for the small sketch. The first of its kind, the fountain received considerable publicity in New York and Texas newspapers. Although it was a difficult project, Waldine completed the sketch before the Christmas holidays, received approval from Mr. and Mrs. Smith, and took pictures of it with her when she went to San Antonio.

In Texas she showed the pictures of her fountain sketch, partied with her artist friends, and spoke to several clubs about her works and those of Coppini, always promoting the use of sculpture for decoration and for memorials.

While Waldine was in San Antonio her sister-in-law, Ruth Tauch, and other women from the Cradle Roll Department of Grace Lutheran Church visited her with a request for a baptismal fount for their new church. She accepted, modeling her small sketch at her parents' home for the women's approval before she left.

More often than not she returned from her Christmas vacations with a Texas commission. Texas, especially Brady and San Antonio, prided themselves on Waldine Tauch, their famous New York sculptress. The following Christmas she received the commission for a bronze bust of Mrs. Eli Hertzberg, the founder of the Tuesday Musical Club and the woman most responsible for contributing to a profound musical culture in San Antonio.

The year 1929 was an especially busy year for Waldine. She worked on several existing commissions, received a new one for a bas-relief for the children's reading room in the Jersey City, New Jersey, library, went to the unveilings of the Smith children's Portrait Fountain and of the Baptismal Fount, of which the original cast was accepted by a jury for display in

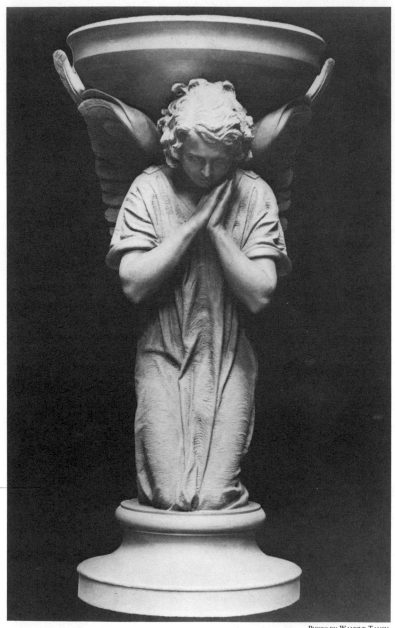

"ANGEL BAPTISMAL FOUNT," 1928, FOR GRACE LUTHERAN CHURCH, SAN ANTONIO, TEXAS.

80

the San Francisco $100,000 Sculpture Exhibition lasting a full two years.

However, prosperity gave a sense of security when there was actually none, and on October 29, while Coppini was showing his bust of the chairman of the New York Board of Trade to a committee, his stock broker called to advise him to sell his stock immediately. Coppini, annoyed by the interruption, refused the call, stating he would call back when he concluded his business. By that time, however, it was too late. The stock market crashed, and Coppini found himself owing a great deal of money on stock.

He confided to Waldine that he had borrowed heavily to invest in stock without telling Lizzie. He had hoped to surprise her with a fortune, but found instead that he was financially ruined. All he owned would have to be sold to pay the debt on his stock — the studio, their home, everything.

"Oh, no! That's terrible," she exclaimed in alarm. "What can we do?"

"Nothing," he sighed in defeat. "There is nothing we can do. We are ruined. Everything I've worked for, everything we have is lost."

"No, I can't believe that. There must be something, some way." But she could see he wasn't listening, so she continued to ponder quietly, searching for a solution.

Waldine finally decided on a plan. First she delivered some of Coppini's money to the brokerage firm and then contacted their good friend Andy Dykes, a wealthy lumberman and a member of the New York Board of Trade. Without hesitation he asked how much money Coppini needed, then made some quick stock transactions by withdrawing the collateral he held in a cab company and putting it in Coppini's name. His friendship was true and his financial means sufficient to rescue Coppini from financial disaster. Five years later Coppini actually realized a profit of $25,000 from his friend's transactions.

Since Waldine owned only a small amount of stock, always sending most of her extra money home for her parents, she was not disastrously affected by the crash, at least not financially. However, the depression which followed affected

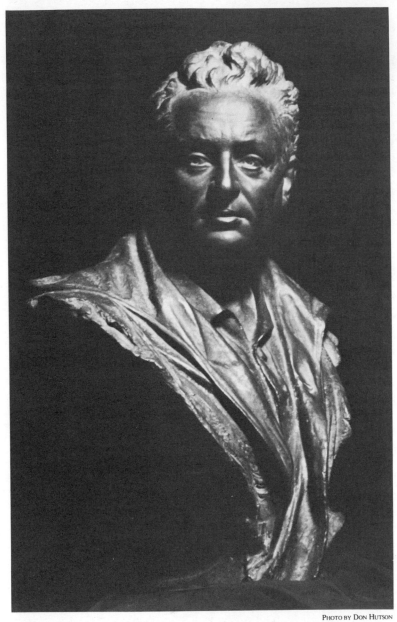

PHOTO BY DON HUTSON

BRONZE BUST OF POMPEO COPPINI CREATED BY WALDINE DURING THE DEPRESSION.

everyone. Those who thought they were securely wealthy suddenly became paupers. Many couldn't stand the pressures, and reports of suicides filled the newspapers. Banks closed overnight, taking with them the life savings of their patrons. Factories and businesses closed their doors, putting people out of work, and when those people couldn't pay their mortgages, banks repossessed their homes.

To save money, Waldine and Coppini rode the subway to and from the studio every day instead of driving; but being buffeted to and fro, sometimes standing for the entire trip, proved too much of an annoyance for Coppini, and so he closed their beautiful home in Pelham Manor and moved back into the apartment. The Depression choked all possibilities of art patronage or even the sale of art by galleries, and artists suffered even worse than they had during the war.

Waldine soon finished the contracts she had made before the crash and spent her free time — of which there was plenty — creating busts of Mr. and Mrs. Coppini and small pieces of her own design just to keep busy. One such creation was a complete desk set of Indian design which was later cast in bronze and exhibited at the Fifty-Sixth Street Galleries. Another was an eighteen-inch model of a young woman symbolizing the ''Gulf Breeze,'' a reproduction of which Harry Hertzberg purchased and donated that Christmas to the Witte Museum in San Antonio.

When the artists' fight for survival looked its bleakest, the New Deal Administration initiated the Works Progress Administration, which came to the rescue of even the sculptors by holding competitions. Waldine entered many of them, hoping for some work to earn enough money to send to her family. Yet time after time she lost the competition; she grew convinced that an artist was awarded a project based solely on his needs rather than on his merit, and her parents' needs were not considered. Finally, however, she received a project to design a bas-relief of George Washington for the library in Mount Vernon, New York. Her interpretation was entitled ''Washington Speaks for Himself'' and was her original idea. To cut her cost as much as possible, she even cast it in plaster herself rather than hire a caster.

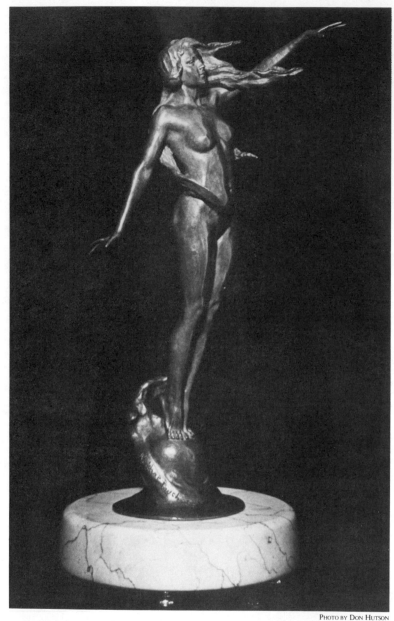

"GULF BREEZE," 1930, AN 18″ BRONZE STATUETTE; SEVERAL REPRODUCTIONS HAVE
BEEN MADE FOR PRIVATE COLLECTIONS AS WELL AS MUSEUMS.

The Depression ended the Coppinis' expensive open-house parties, and on Sundays the studio filled instead with fellow artisans living in the apartment building who did not expect to be entertained lavishly but who sought camaraderie and an understanding of the ordeals they experienced. When David Mueller rented a small studio apartment, Waldine soon discovered that he, too, was an artist — a painter — and she invited him to join their Sunday group. He accepted immediately, and she felt especially glad.

Surrounded by artists for most of her life, meeting another artist should have been of no consequence to Waldine. Yet she realized from the beginning that David was different. She delighted in their conversations, whether they agreed or not, and she anticipated his visits with an eagerness that baffled her. And she sensed that he enjoyed her company as much.

Whenever David completed a new painting, she saw it first. If she couldn't go to his apartment, he carried the painting down to the studio for her approval. When he introduced her to Julia, a friend he had met while attending art school, she felt foolish for the stab of jealousy she experienced toward this woman who had known David longer than she. However, the three of them became close friends, often sharing their weekends at the beach or in some other leisure activity, and of course they shared a keen interest in the arts, traipsing about together to museums and art galleries.

She often wished Julia would find a boyfriend of her own, so they could become a foursome, but since there were sufficient opportunities for Waldine and David to be alone, she never thought their mutual friend an imposition. Not, that is, until one evening when the two women were together, without David present, and she discovered that Julia intended to marry her David.

Waldine was shocked and confused, for she had never suspected Julia had any such notions. She herself was in love with David, and he had professed his love for her. She was the one waiting for a proposal, and this time she knew she wouldn't hesitate to accept.

"I didn't know you felt that way," Waldine began cautiously.

"Oh, my, yes. Hasn't he ever told you?" she asked. "We've been talking about getting married since we were in art school. Of course, then we couldn't afford marriage, and now with the Depression and all, well, things aren't really much better. But then on the other hand, since they can't get much worse, and we don't know when they'll get better, there's really no point in waiting, is there?"

What? Waldine thought in alarm, David had never indicated any such relationship to her. Was Julia imagining something which didn't exist, she wondered, feeling the room begin to spin about her, hearing a voice calling out to her.

"Waldine, I said there's really no point in waiting, is there? Waldine? Are you all right? You look pale."

She could hear Julia's voice droning on and on, but the words ran together and made no sense. The air became oppressive to her, suffocating her, and she suddenly felt a compulsion to run from the room.

"I don't feel well. I think I'll lie down for awhile," she explained as she rose to her feet and quietly slipped out of the room.

Alone in her bedroom, she thought over the words she had just heard, trying to make sense of them. What was David's involvement, she wondered. She couldn't believe her friend had lied to her, and yet, if she hadn't lied, then why had David never mentioned the relationship? She could find no answers and finally decided to talk to David.

"I need to know," she began reluctantly, "how you feel about Julia?" She felt awkward and embarrassed.

Shrugging his shoulders casually, he replied, "You know how I feel about her. We're good friends, that's all. Don't tell me you're jealous of her?" he chided, putting his arm around her shoulder affectionately. "You know I love you. Look," he continued, "I have some news I was saving, but I think this is the best time to tell you. I'll be leaving soon for art school in Paris. Marry me, and we'll go together."

An uneasy feeling that he never completely answered her question foreshadowed his proposal and plans for Paris. How could Julia have assumed a relationship if there actually never had been one? She needed an answer, a definite one.

"But, David, Julia said you and she have talked about marriage. Have you been stringing her along, or what? I've got to know," she pleaded.

"Marry her? Why, it's you I love. Oh, sure, we dated a lot while we were in school, and I guess we did discuss marriage, but that was years ago, before you came into my life. It's all over between her and me."

"David, she doesn't know that! She thinks I'm just another friend; one who, incidentally, is always around so you can't pop the question to her. You can't just drop her like that. She loves you very much."

"You're right, of course. I've handled things badly. I think the world of her, and I just didn't know how to go about breaking it off."

"You still love her, don't you?" Waldine asked, but it was more of a statement, and a lump grew in her throat.

She saw his look of consternation and knew it was true. She sympathized with him, for she knew how difficult it must be to love two people, to have to hurt one of them to fulfill the love for the other. She realized what she must do.

"David, go back to her. You still love her, and she wants to marry you. I've always been so involved in my own career that marriage has never been in my plans," she lied. "You two can share a beautiful life together."

She reached over, kissed him gently on his cheek, then rose and walked out without giving him a chance to argue, for she knew she had given him the only solution.

Within a few weeks David and Julia were planning their wedding. Meanwhile, Waldine silently suffered the gripping agony of her sacrifice. She avoided her friends as much as possible, and when she did see them she struggled to behave casually, as if no pain clutched her heart. She was determined that David should never know her pain.

The wedding was small, with only members of the family invited, and Waldine was relieved that she did not have to attend. So David would know she harbored no hard feelings, she gave them a beautiful and especially expensive gift.

Because she hid her feelings so well, no one ever knew the depths to which her torment hurled her. No one knew that

once she considered throwing herself in front of an oncoming subway train to end her anguish. No one knew, and she hoped that no one ever would.

Despite her despondency, Waldine's career continued to move and, therefore, to move her. On November 28, 1930, she unanimously passed a twenty-five-woman jury and was accepted for membership in the prestigious National Association of Women Painters and Sculptors. Through that organization she met and made new friends with many great women artists, including Ruth Nickerson, who became her very close friend. They often went together to exhibits and art galleries, and her new friend filled the void which David had left.

Meanwhile, the New York Texas Club was eagerly discussing plans for the Texas Centennial in 1936. Many of its members urged Waldine and Coppini to return to Texas to insure receiving their share of commissions for the monuments.

When Mrs. W. N. White, the wealthy and influential clubwoman from Brady, insisted that Waldine return to Texas, Waldine accepted, hoping that leaving New York would help her forget David.

The night before she left, friends took her out for a farewell dinner and then, just for fun, to a tea room where a lady read her tea leaves. The reader surprised Waldine when she predicted, ''You are going South and great things are in store for you. You will make a great name for yourself, but you will not travel by train.''

While not admitting to believing such nonsense, she was astonished that two of the reader's predictions were true, for her bus ticket to Texas was in her purse.

VIII

ARTFUL POLITICS

THE FACT that the bus held together in spite of rough roads, detours, and bad weather surprised Waldine as much as their two-hour-late arrival didn't. She stumbled off the bus, tired and disheveled and looking quite like a ragamuffin, certain there would be no one still waiting for her. However, Mrs. White sat patiently in her chauffeured limousine, crisp and fresh, as if she had just arrived.

The chauffeur delivered the ladies to the hotel. Waldine, although exhausted, yearned to hear about the girl friends of her youth in Brady, and Mrs. White accommodated her, telling her who had married whom, how many children each had, and what their husbands did. As Waldine listened, she felt a pang of envy for her married friends and found herself envisioning her life as it would be if she were married to David. She mused, more to herself than to Mrs. White, "Maybe I should have married, too."

"Oh, Waldine, don't be ridiculous," Mrs. White admonished. "You're too tired tonight to even think straight. Go to bed and sleep on it and tomorrow we'll visit some of your girl friends who did marry. Then you can decide whether or not you should have. You're only forty-three, so it's really not too late to change your mind."

The next morning the chauffeur drove the women to Brady, and as promised, Mrs. White took her to see several of her old school chums, all of whom had married. A few of them were too busy with their house chores and children for a long visit, but several had time for a relaxed conversation, and Waldine asked them about their lives, searching their answers for her own. What did they do with themselves? What gave them a sense of accomplishment? What did they find in life that was exciting?

On the drive to Mrs. White's house, she pondered their answers silently. Housework seemed to take up most of their time and she couldn't understand why, because she too did housework, but it certainly didn't take her all day. Yet for several of her friends, to judge by the sounds of their sighs, housework left them no time for anything else.

Some were fortunate enough to have maids to handle the housework, so they were free to do something else with their lives. But what? They busied themselves with church and club work, more to fill their days than to accomplish anything important or lasting. She too was involved with church and club work, being an active member of over half a dozen organizations. But that didn't fill her days. Their joys were social events or the accomplishments of their husbands or children, but never their own accomplishments. Was that all she had missed, she asked herself, and wondered if Julia would find it necessary to give up her art career. It would be such a waste of talent, thought Waldine, and found relief that her own career was not so threatened.

"Do you still wish you had married?" asked Mrs. White at the end of their drive.

"Well, I think my friends are happy, but my life has been productive and rewarding, and adventuresome too, and I don't think I would want to trade with any of them."

At last she felt more comfortable with her decision, even though there were times, and she supposed there always would be, when she ached for David's loving arm around her. She had many friends who loved her, and she allowed their love to compensate. She knew hard work and zealous dedication could obscure the hint of loneliness within her.

But there was no time to dwell on what might have been, for Mrs. White arranged a busy lecture tour for Waldine at men's and women's clubs in Brady, Lubbock, Houston, Dallas, Fort Worth, Austin, San Antonio, and Brownwood. Waldine needed to acquaint herself, according to Mrs. White, with as many politically important people and civic groups as possible to solicit their support of her for Centennial commissions. She felt like a politician campaigning for her own election, and in a sense she was. She didn't enjoy promoting herself in that manner but knew it was necessary in order to insure her future success. She desired to be judged only on her merit, but since politicians had always played favorites, being one of their favorites became extremely important.

Life became hectic as she commuted between Texas and New York regularly, giving speeches in Texas and holding exhibits in New York. As a member of the Society of Medalists, the Southern States Art League, the Artists Professional League, and the National Association of Women Painters and Sculptors, constant demands were made on her time. And despite all else, she continued her sculpture work, not only because she had contracts to complete, but because that was the purpose of everything else.

Her brother, Werner, and his three children moved in with his parents after his wife died, but Waldine nevertheless maintained her studio at their home to work on sketches for the various competitions. The commission for the "Pioneer Woman" was one which she especially wanted, and her friends throughout Texas exerted their influence to insure that she got it.

After studying the State Board of Control list of desired statues, she decided to design and create miniature sketches to enter into seven competitions. She made sketches of Moses Austin for City Hall Square in San Antonio, Mr. and Mrs. Van Zandt for Canton in Van Zandt County, the First Shot Fired for Texas Independence in Gonzales, the Pioneer Woman for Denton, and three others.

Waldine knew that although a sculptor's sketch is only a miniature of the finished heroic-sized monument, it must be complete in every detail and cannot be done rapidly, for getting

a commission depends upon the perfection of the sketch. After deciding which commissions she would seek, she then thoroughly researched the characters and the history to be immortalized before she designed her original conceptions from which the sketches would be made.

She traveled to Gonzales to speak to families whose direct ancestors fired the first shot for Texas independence. She searched through the local library for little-known facts concerning the episode and the men involved and took pictures of the actual cannon used.

She depicted Moses Austin at his most important moment in history: standing with outstretched hand holding the rolled document which gave him the right to settle Anglo-Americans in Texas. Around the octagonal base were four pictorial bas-reliefs: the pioneer family that would colonize Texas; successful crops that would be grown; the actual meeting of Austin with the Baron de Bastrop, as Bastrop hands him the important document; and Moses' son, Stephen F. Austin, carrying out his father's dream of colonization, for Moses Austin died of pneumonia on his journey home.

As the date for the competitions neared, Waldine spent all of her time sculpting her seven sketches, with her four-year-old nephew, Carl, watching in admiration.

"I'm going to be a sculptor, too," he proclaimed, "when I grow up."

"Well, don't wait that long," she cautioned, handing him a piece of soft clay.

Two days before the deadline she completed her sketches, and, able to relax, she accompanied some gentlemen on the committee to Gonzales to see the site selected for the monument, content that her sketches were ready to be delivered to Austin. When she returned that afternoon she was horrified at what she discovered.

She screamed at the sight of her sketches, beautiful when she had left them, but changed somehow into grotesque monsters. Most of the faces and hands had been intentionally smoothed out, ruined. "But who could have done such a terrible thing?" she gasped through her tears of anguish. "Who could hate me so much?"

Her screams and shouts awoke her mother, who was not feeling well and was napping. It looked indeed as if a competitor had sabotaged her chances for the competitions. But who? As Waldine and her mother stood bewildered, they saw the culprit. He had not yet made his escape, particles of clay still clinging to his clothes and hands, a look of fright upon his face. He meant no harm. He only wanted to be a great sculptor — like his Aunt Waldine.

Werner discovered what Carl had done and prepared to whip him soundly, but Waldine intervened on the child's behalf, relieved at least to know she had no jealous enemy but instead a child wanting to imitate his idol. But what a way to be complimented, she thought with chagrin. After saving the child from punishment, she concentrated on saving her sketches, a task which seemed impossible. She had spent weeks creating them; could she repair them in only two days?

She thought of the Chicago incident, and without questioning possibilities or impossibilities, she set to work with a determination that on other occasions had also provided her with an extra surge of energy. She worked continuously through that night, the next day, and the following night, catnapping periodically to revitalize herself and continuing with stubborn resolve.

On the morning of the competitions she finished the last sketch, and while her niece, Gertrude Slaughter, drove her and her works to Austin, she dozed in the car, totally exhausted but satisfied with the results of her labors.

The two women set up her works on pedestals in the basement of the capitol building alongside the many other entries. Sixty-seven sculptors from throughout the nation entered one competition alone, and the other competitions seemed equally represented. As Waldine glanced about the huge room at the hundreds of works, her heart sank, for she had no idea the rivalry would be so keen, nor the contenders so plentiful. Would the judges select even one of hers, she wondered with sagging spirits. Did she have any chance? There was nothing more she could do but wait. And worry.

Days passed with no news from Austin, and her doubts increased. At the end of a full week of nervously waiting and

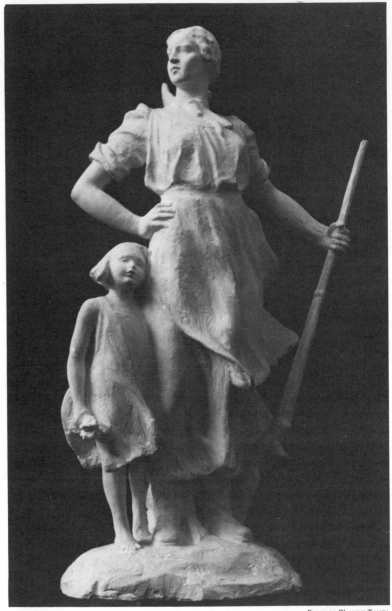

"PIONEER WOMAN," 1935, FOR THE TEXAS CENTENNIAL COMPETITIONS. ALTHOUGH
WALDINE'S SKETCH WAS NOT ACCEPTED, MANY BRONZE REPRODUCTIONS WERE MADE AND
SOLD.

still no news, she felt that her repair job must not have been good enough. She had been so tired, she recalled wearily, that perhaps she had not been enough of a critical judge. All the time she had spent, all the money, everything was lost. Her hopes for receiving a commission died, for surely by that time the Board of Control judges had made their decisions, and obviously none of her works were selected. It was a crushing defeat.

But Waldine had not reckoned on how slowly the wheels of government can sometimes turn, and just as she gave up all hope, an official letter arrived telling her she won the ''First Shot Fired for Texas Independence.''

A few days later she learned that the competition for the ''Pioneer Woman'' was awarded to a sculptor whose interpretation depicted not just a pioneer woman but an entire pioneer family in the nude. She was shocked at that conception, although she accepted nudity as part of art and often created nude statues. She felt, however, that nudity belonged with classical figures of gods and goddesses or with symbolic portrayals of abstract beings; the portrayal of a nude pioneer family seemed outrageously ludicrous.

She wasted no time telephoning and writing letters to many of her friends throughout the state to report the incident. The news spread quickly and both men and women reacted with indignation, flooding the offices of their governor, congressmen, and the State Board of Control with furious letters. The news media effectively aided in spreading the story, and soon the Board of Control, embarrassed by the scandal it had caused, announced that there was no winner for the ''Pioneer Woman.'' After the uproar died down, however, the commission was given quietly and without publicity to Leo Friedlander, a sculptor who had not even entered the competitions.

Waldine and other sculptors who had properly entered the competitions felt the Board handled the situation improperly from the beginning to the end; however, none pursued the matter further for fear of tarnishing his or her own reputation.

About the same time that Waldine received the commission for ''The First Shot,'' Coppini was awarded the

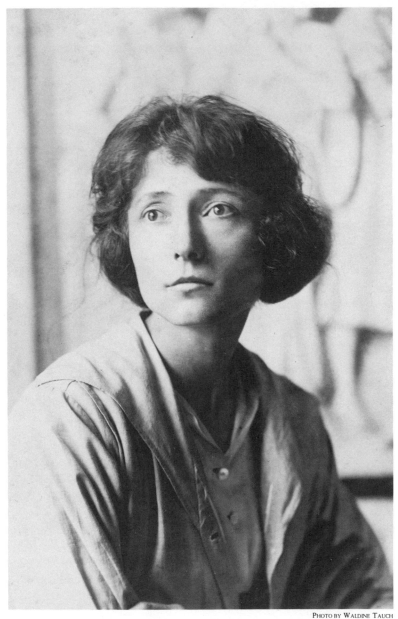

SELF-PORTRAIT OF WALDINE, 1936.

statues for the Alamo Cenotaph, which was designed by the architect Carleton Adams and, against Coppini's wishes, was to be made entirely from Georgia white marble instead of Texas granite with bronze figures. Because of the prohibitive cost of creating the figures in New York and then shipping such a huge work to San Antonio, Coppini discussed with Waldine the idea of splitting the cost of building a studio in San Antonio. Joint ownership of a studio intrigued Waldine, for she realized they would then be true partners, sharing their careers and their expenses. When she received a second letter from Austin awarding her both the "Moses Austin" and the "Van Zandt" memorials she knew she could afford the expense, and with the new commissions she definitely needed a full-sized studio in San Antonio.

However, since the City Zoning Commission considered an artist's studio a business, a number of ideal residential sites were unavailable for their purpose, and they could find no location in a business-zoned area which suited them. After spending much of their time looking at real estate they decided to go outside the city limits and purchased a parcel which was almost in the country, at 115 Melrose Place, hiring Carleton Adams to design the studio and living quarters.

Meanwhile, Waldine worked in the New York studio on "The First Shot," since that monument was requested for an early unveiling. The studio at Melrose Place was completed in the early part of 1936 and all of Waldine's and Coppini's new works were created there, although Coppini retained his New York studio. He began his statue of R. E. B. Baylor for Baylor University while she worked on the Moses Austin.

After she completed the nude figure in clay, she shaped his clothes except for his gigantic cape. For the cape she draped a metal lath upon the back of the statue, carefully bending it to shape the folds. The edges of the lath were razor sharp and working with it was an ordeal, for it cut her hands so viciously that every night when she finished her hands were bleeding. The next day the lath sliced into the scabs and made fresh wounds. Finally, when the lath was properly arranged on the statue, she covered it carefully with gauze, then painted it with shellac so that it kept its shape while she applied clay.

"FIRST SHOT FIRED FOR TEXAS INDEPENDENCE," 1935, NEAR GONZALES, TEXAS, WALDINE'S FIRST TEXAS CENTENNIAL COMMISSION.

98

After a year and a half of work, Waldine finished the Austin statue and the plaster mold was cast all in one huge piece. She inspected the mold, crated it in an immense box, and shipped it to the bronze foundry in New York City by freight express. She felt relieved to have her part of the job on the statue finished, yet she could not relax, for she still had to create the pedestal with its bas-relief panels. She started immediately so the deadline would be met.

However, the foundry was busy with other works and did not immediately open the crate. When they did, they sent Waldine the following telegram:

LEGS OF STATUE BROKEN STOP WORK SUNKEN STOP STATUE BADLY INJURED STOP PLEASE ADVISE STOP

She paled and slumped into a chair, unable to speak or think, as she stared down at the ominous yellow paper in her hand.

"What's the matter?" Mother Coppini asked in alarm.

For a moment Waldine said nothing, afraid that speaking the words would make them true and silence would obviate reality. "My work has been ruined," she finally cried, anguish racking her body. "What can I do?"

Hearing the outburst, Coppini rushed into the room to investigate the commotion, but she was crying so frantically her words were incoherent. Mrs. Coppini, her forehead furrowed with concern, supplied, "It seems her statue is ruined."

Coppini became enraged. "What? Who's responsible? Nothing like this has ever happened. We'll sue."

"Oh," she wailed, "money won't repair the damage. What'll I do? There's no time to have it recast and I can't go to New York now to repair it. I've got to finish the pedestal." Then the irony struck her, "But what for? There'll be no statue to set upon it. Oh, I just can't think."

"Well, now, first calm down. My own work is going smoothly and I'm ahead of schedule. I'll go myself and do what I can to repair the mold," he offered.

"Oh, would you?" She hadn't expected such an offer, but immediately knew it was the answer to her problem. He would be

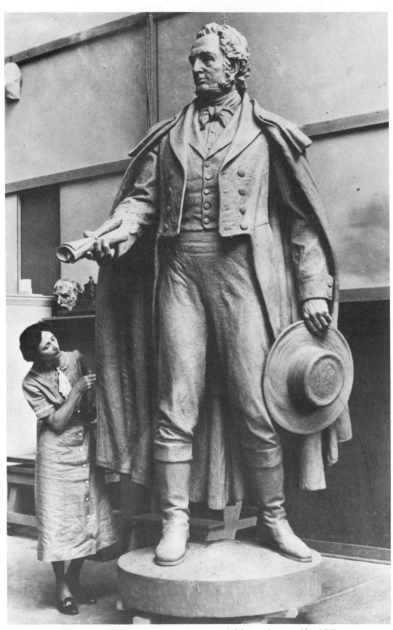

WALDINE ADDS FINISHING TOUCHES TO "MOSES AUSTIN," 1937.

able to take care of it, she knew, as she wiped her eyes and smiled up at him, feeling the warmth and assurance of his love. "Thank you so much. I don't know what I'd have done."

Coppini left the next day for New York and Waldine got back to work on her bas-reliefs, confident that all would go well. She completed the four bas-reliefs depicting the life of Moses Austin and began the laborious work of printing the other four, which were to be inscribed with wording the committee furnished her. She detested lettering and was not especially talented at it, but the inscriptions were part of the job and had to be done. Each letter had to be painstakingly precise in its shape and spacing. She considered it a purely mechanical chore that insulted and inhibited her creativity. After weeks of hard work she completed the drudgery and was even proud of her work, although she hoped she would never have to do such a job again. She studied the panels with a critical eye and, finding no errors, no imperfections in shapes or spacings, called the committee for their final approval. A committee always gave a final approval on a work before it was cast so that if anything was wrong, the problem could be corrected in the clay without an added expense of having it recast. She was eager to have the committee come, for she knew there was nothing wrong with her work, and she was anxious to begin the Van Zandt. She felt she had spent too much time already on the Moses Austin.

The committee, all ladies, came into the studio and sat down, studying the four pictorial bas-reliefs and praising her work, but Waldine suspected something strange in their behavior. Then she realized they seemed to be avoiding even a glance at the four inscribed bas-reliefs. She didn't understand.

"The inscriptions are finished, too," she offered, forcing their attention to the bas-reliefs that had caused her the greatest amount of work and the least enjoyment.

The women lowered their eyes as if in shame, but one finally spoke up, "The writings will have to be redone," she said quietly.

"What?" Waldine cried out in indignation. "Why, you haven't even looked at them!"

"There's been some new information discovered that wasn't in the original writings. I'm sorry about the in-

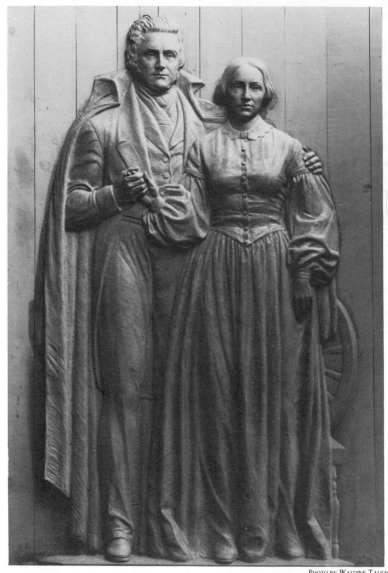

PHOTO BY WALDINE TAUCH

"ISAAC AND FRANCES VAN ZANDT," 1938, HIGH RELIEF FOR CANTON, TEXAS, IN VAN ZANDT COUNTY.

convenience, but it will have to be added,'' the committeewoman stated regretfully as she handed the paper with the new wording to Waldine and rose to leave with the other women following closely behind her.

Shocked, Waldine watched the ladies walk out of the studio, speechless to protest. Anger slowly welled up until she could no longer contain it. "Sorry, are they?" she stormed. "A slight inconvenience, is it?" She raged about the studio, viciously scratching off the unwanted inscriptions from the plastilina background, and when each of the four panels was smooth and without letters, her anger subsided and she felt nothing but weariness. All that lettering to do over again, she thought, and there would be no extra money for the extra work she had to do because of the committee's irresponsibility. Well, that was a sculptor's life, she told herself; the life she had chosen.

After the new inscriptions were made, approved, and sent to the caster, she began the Van Zandt memorial, the last of her Centennial commissions and the only one which gave her no problem.

On May 15, 1939, more than two years after she received the commission, the Moses Austin was unveiled in an elaborate ceremony sponsored by the Battle of Flowers Association, the Governor's Palace Board of Directors, the San Antonio Conservation Society, and the Canary Islanders, assisted by the Daughters of the Republic of Texas. The Conservation Society and the Canary Islanders, all wearing old Spanish costumes, staged a procession to the monument styled after celebrations in Old Mexico. Waldine walked in the place of honor beneath a canopy of flowers, and when the women had reached the monument they laid wreaths of flowers at its base. Terese Lewis, the great-great-great granddaughter of Moses Austin, then unveiled the memorial to the applause of over four hundred people, with a Mexican orchestra playing. Waldine and the descendants of Austin were honored after the ceremony with a reception in the gardens of the old Spanish Governor's Palace. It was the most beautifully staged unveiling Waldine ever attended.

The statue was lavishly publicized in the newspapers and her mailbox filled with letters of praise, such as the following from Harry Hertzberg:

Dear Waldine:

For the second time since it has been unveiled, I went to see Moses Austin — the first time alone, the next time in company with a gentleman from New York. I am not given to flattery, but I want to say that I consider this a grand piece of work. In fact, it is one of the most outstanding of any on the public squares or parks of the country. Here you have done something that I think will entitle you to rank high among the sculptors of the country. Everyone has words of praise.

I heartily congratulate you and want you to know that I am very proud of you, both as a friend and a Texan.

<div align="center">Sincerely yours,</div>

<div align="center">(signed) Harry Hertzberg</div>

The favorable reception of her work helped her forget all the agonies she endured during the creation of the Moses Austin, and she was once again proud to be a sculptor.

IX

DETOURS AND INTRUSIONS

PROJECTS FOR the Centennial brought together many painters, sculptors, and architects, and their close relationships were sustained after the celebration ended and all their works were unveiled. One of the artisans, Hugo Pohl, who painted the mural in the Municipal Auditorium and maintained the San Antonio Art Academy, encouraged fellow artists to join him in his expansion plans. Several were enthusiastic, including Waldine, who agreed to teach sculpture. Notable among other artists who were involved with the new school were Harry Anthony de Young, the landscape artist who did the large wall painting, ''Chuck Time on the Lazy R,'' in the Rainbow Terrace of the St. Anthony Hotel, and Miss Lonnie Rees, who designed many of the book jackets for Houghton Mifflin.

In the Fall of 1939 Waldine began teaching classes at the school, but because of her private works and career she decided it would be easier to teach students in her own studio, especially since the Coppinis moved back to Pelham Manor and she had the studio to herself. Her class grew to about twenty students, among them Louis Rodriguez of Rodriguez Brothers Monument Works, who furnished the granite base on which her Moses Austin stood and to which her bas-reliefs were

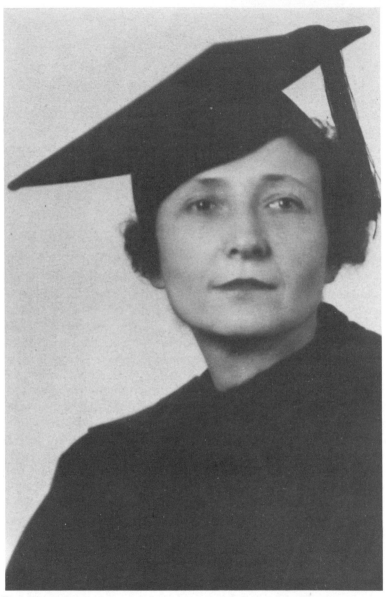

WALDINE IN CAP AND GOWN TO RECEIVE HER HONORARY DOCTORAL DEGREE IN FINE ARTS FROM HOWARD PAYNE COLLEGE (NOW UNIVERSITY) IN 1941.

fastened. Elsie Halbardier (who later became Elsie Fitzgerald, then Shermeer) also studied under Waldine, enhancing her education and career.

Indoctrinated by Coppini's dedication to promoting classical fine art and zealous opposition to abstract or stylistic art, which she also found to be "an irritation to the eye and an insult to the mind," she accepted all invitations to speak before clubs and organizations, expounding her ideal that "every form of art must say something of significance in such a way as to create poetry and stir the soul." She used every opportunity to convince patrons of the arts of the credibility and permanence of fine arts, promoting both appreciation and sales. Through her lectures, interviews with reporters, exhibits, classes, and personal contacts, she relayed her message. Her position was firm and no modernists approached her.

She gained recognition in *Who's Who* in 1940, and on May 28, 1941, was granted an Honorary Doctorate of Fine Arts degree by Howard Payne College, only a few months after Coppini received the same degree from Baylor University. Neither wore the title of "doctor" immediately, concerned that it might sound pompous, but they were gratified with the honor bestowed upon them and eventually were persuaded to use it.

To repay the honor and possibly to clear out his crowded New York studio, in 1942 Coppini donated to Baylor forty-four of his original plaster works from which the bronze statues had been cast. The statues were taken apart from their bases, crated, and shipped to the University. As was expected, many pieces arrived chipped or cracked, but since Waldine planned to supervise the assembling and placing of the pieces, she agreed to do whatever retouching was necessary. It shouldn't take more than a few weeks, she thought, and since she knew many members of the faculty and their wives, she looked forward to her stay.

However, when she arrived in Waco and uncrated several of the boxes she was horrified to discover that the damage was extensive. Repairing the works would take months instead of weeks. Resolutely she moved onto campus into the social atmosphere of the teachers' quarters and was considered a part

of the permanent faculty with a temporary studio on the top floor of nearby Neff Hall.

She worked diligently on the four eight-foot statues of Travis, Austin, Houston, and Rusk, the first ones to be mounted and placed in the Texas Collection in Pat Neff Hall. To give them a finished appearance and to protect the plaster from further chipping she painted each with several coats of shellac.

When Waldine had been at the school for nearly six months, in April of 1943 she received a telegram. Telegrams frightened her, for they usually implied bad news, even though she often received them congratulating her for a recent accomplishment. But that day there was no reason for congratulations, and she knew unmistakably that the yellow paper would curtly hammer out its message of misfortune, illness, or worse yet. She ripped open the envelope before she thought further of the ''worse yet'' and read:

MOTHER VERY ILL STOP MAY NOT LIVE THROUGH NIGHT STOP URGENT YOU COME AT ONCE STOP ERNA

Her heart pounded rapidly, pumping blood and vibrations throughout her body and sending a message of panic to her consciousness. Quickly she pulled a suitcase from beneath her bed, threw it on top, flung it open, and stuffed it with a few dresses and other clothing she thought she would need for the trip; however, she was not thinking well and wasn't sure what she should take or even what she had just put into the suitcase. Overcome by her own suppressed hysteria, she shut the lid, latched the case, grabbed her coat, and headed for her car.

It was already late in the afternoon, and the trip would take at least four hours if she didn't drive faster than the speed limit. But she often sped to a destination at eighty miles per hour even when she wasn't so eager to arrive; she found it quite impossible now to hold her speed down to the legal sixty. She didn't even try, but instead kept a watchful eye for Highway Patrolmen each time she topped a hill. She arrived at her parents' home just before dusk, less than three hours after leaving Waco, and pulling to

a stop, realized the tension she had been under had left her with such a severe headache that each slight movement caused her excruciating pain. But she remembered her mother and, in spite of her own agony, got out of the car quickly and walked swiftly into the house.

Faces sagging with despair filled the room and eyes wet with recent tears met Waldine's.

"How is she?" Waldine asked, fearing she was too late after all.

Erna moved toward her with arms outstretched. "I'm so glad you made it. Mother's resting, but the doctor says it's just a matter of time. Come, I'll take you in to see her." Erna slipped her arm around her sister's shoulders as they walked to their mother's room, not speaking, for words could not be adequate to express their emotions.

Mrs. Tauch's eyes were closed as if in sleep, so Waldine sat quietly in a chair beside her bed and Erna left the room. How can it happen, Waldine agonized, that a lifetime passes and two people who love each other never find time to express their love? There was so much she wanted to thank her mother for, so much she wanted to explain, and so much she wanted to say she understood. She felt the anguish of hopelessness, the possibility that her mother would not awaken and she would have no chance to say the things that filled her heart.

Suddenly she noticed a quiver in her mother's eyelids and a slight, almost imperceptible movement in her hand, which laid atop the blanket. Waldine quickly, but gently, placed her own hand on her mother's and watched carefully for signs of awakening. Her mother's eyes opened slowly with apparent effort and a mere tremble of her lips indicated a smile.

"I love you, Mother," she spoke, quietly sincere, realizing by the expression of content upon her mother's face that that said it all and was all that was needed between two people who in their own way loved each other for a lifetime.

Waldine retired that night exhausted and spent of all emotions. At eight o'clock the next morning, before Waldine awoke, her mother passed away in her sleep.

She stayed for the funeral and several days afterward and then returned to Baylor to finish her work.

On March 18, while Waldine was still at Baylor, Coppini received a visit from President Monroe G. Everett and Dean Paul Schwab of Trinity University; they wanted him to head their Art Department.

"Haven't you been told by anyone of my objections to primitive art and my constant fight against it?" he remonstrated, knowing that most schools of higher education were no longer interested in classic fine art.

"Yes, yes, but I assure you that what you believe in is exactly what we want," replied Dean Schwab emphatically.

"Well, if I take the position, the university will have to accept the challenge I'll provoke to the modern primitive schools. It may make your institution rather unpopular."

"We accept your challenge. Consider yourself the new head of the Art Department," President Everett concluded, and the deal was consummated with a handshake, Coppini not even thinking, or caring, about the salary he would receive.

Because of World War II, Trinity operated at that time with meager funds, but when Dr. Coppini began teaching his large classes and realized he needed an assistant, President Everett granted him permission to hire whomever he pleased. Naturally, he wanted Waldine to work alongside him as she did in the past, and a month later she returned from Waco to discover that at the age of fifty-one she was about to embark upon a new career.

Her extended stay at Baylor, however, made her especially receptive to a university experience, and she accepted Coppini's proposal enthusiastically. She soon found teaching in a university environment more stimulating than she expected, as her students constantly amazed her with their talent and dedication. Many of them later became accomplished artists and one, John Silber, became president of Boston University. The dismissal bell meant nothing to the students, who often stayed to complete a project or just to chat with Waldine or Dr. Coppini. Even students who were studying other artistic forms, such as poetry and music, continuously wandered in and out of the art classroom to browse, particularly a promising young poet, John Igo, and a pianist, Brooks Smith. Waldine's students thought so much of her that the first

January she was there they planned an elaborate surprise birthday party to honor her.

Waldine immersed herself completely in her role of professor, not only with her students but the faculty as well. She joined the teachers' organization and because of her artistic talents was often asked to handle the decorations for meetings, conferences, and graduation ceremonies. Since the school had no money available for decorating, she used her ingenuity, and Mother Coppini's flowers, to create masterful floral arrangements.

She also was invited many times to speak to the American Association of University Women on fine art or on her own life as an artist. In the midst of the Second World War she spoke often on the importance of teaching art during wartime and on the necessity of preserving the fine arts from deterioration during the war.

Dr. Coppini and Waldine began the Classic Arts Fraternity, which was later renamed the Classical Fine Arts Fraternity, at Trinity to encourage young people to work in the arts, especially painting and sculpting. The students were enthusiastic and dedicated in working toward a career in art, but a year or two later, when many of those same students entered into other professions or married and gave up their art careers altogether, Coppini became disillusioned with teaching, and in 1945, at the age of seventy-five, he resigned. Waldine also resigned so she could return to her own career as a sculptor. The first work she completed after leaving Trinity was a bronze bas-relief of J. A. Walker for the new Walker Memorial Library at Howard Payne College, unveiled in 1946.

She often enjoyed working alone in the studio at night while Coppini attended one of his many meetings, and one night, unknown to her, Mother Coppini's dog, Trixie, followed her. While Waldine was busily working on the finishing touches of her Walker bas-relief, she occasionally heard strange sounds, which at first she ignored. As the sounds became more frequent they aroused her annoyance and curiosity. Was there a mouse in the room, she wondered, as she began cautiously searching for its source. Shortly she discovered the noise was only Trixie contentedly gnawing on a

111

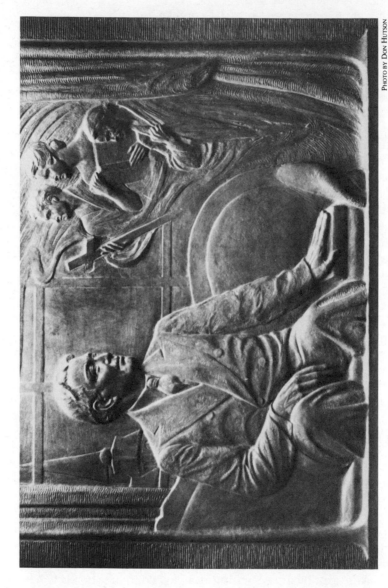

"John Allen Walker," 1945, bas-relief in the Walker Memorial Library on the Howard Payne University campus in Brownwood, Texas.

bone. A perfectly natural thing for a dog to do, she assumed, as she resumed her work. But then she suddenly realized there were no bones in the studio!

Taking a closer look at the bone Trixie had nearly devoured, she saw with alarm that the dog was chewing the toes off the skeleton Coppini had borrowed for his classes from a well-known surgeon. Three toes were missing! She was frantic, knowing Coppini would be furious with her and so would the doctor. What could she do? In desperation she carved the three toes from pieces of persimmon wood, which is light colored and easy to carve. When she had finished, she bored holes through each "toe" and wired them onto the skeleton. A perfect match, and she was amused that no one ever noticed the skeleton's new toes.

The Classical Fine Arts Fraternity dissolved after Waldine and Coppini left Trinity, yet Coppini was still interested in forming an organization that would perpetuate his ideal of classical art through association and exhibition. That same year they founded the Academy of Fine Arts, "academy" referring not to a school, but to an older meaning: a society of learned persons organized to advance art. Those artists invited to join would have to be of one mind in their dedication to classical fine arts rather than being practitioners of abstract or contemporary art. Among the earlier members were many well-known artists such as Rolla Taylor, Porfirio Salinas, Harold Roney, Merrill Doyle, Bruce Harper, Elsie Fitzgerald, Hugo Pohl, and Melvan Jordan.

The members of the Academy met regularly in the studio on Melrose Place, worked diligently at exhibiting their collective works in museums and art galleries throughout Texas, and enjoyed a fraternal kinship.

Meanwhile, Coppini, always a meticulous man who saved every letter and newspaper clipping until his files bulged and overflowed, spent his latter years at Pelham Manor writing his memoirs. After five years of work, in 1949, he published his autobiography, *From Dawn to Sunset.*

During that time he returned often to Melrose Place where he created his own memorial, a double crypt for him and his beloved wife, Lizzie, to be shaped as a sculptural

"AFTER THE BATH," 1946, RENAMED "SATURDAY NIGHT" BY ONE OF WALDINE'S STU-
DENTS, WHEREUPON ANOTHER STUDENT OBJECTED, RENAMING IT "EVERY NIGHT." THE
4'5" PLASTER STATUE IS IN HER STUDIO.

114

"Clinging to Youth," 1945, a 23″ statuette in plaster.

115

DR. POMPEO COPPINI, 1957, SHORTLY BEFORE HIS DEATH.

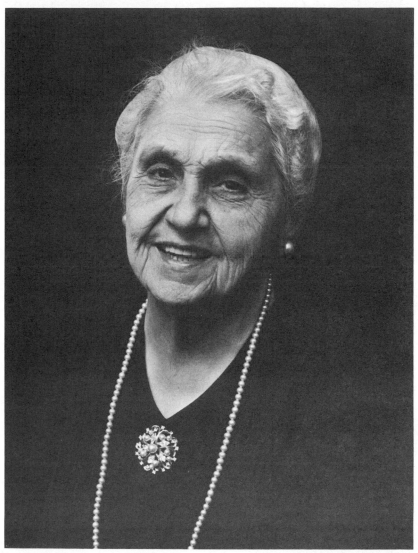

Mrs. Pompeo Coppini, 1957.

memorial having a large bronze front with life-size figures. "Can you imagine such conceit?" he asked with a broad grin, but his many friends were delighted with the project and with his stamina.

He not only received special permission to erect his memorial at Sunset Memorial Park in San Antonio, but the owner, Robert G. Early, was so thrilled that he gave Coppini the land. Waldine and Mr. Early's daughter, Paulette Early, unveiled the memorial in 1953 with Carmine Luce leading the 657th Air Force Band.

Dr. Pompeo Coppini was now an old man intent on having all debts paid and all details attended to before his death, which, since he was in his eighties, he knew was near. With his autobiography written and his own memorial created, he traveled to his hometown of Moglia in Italy to carve the "Martyrs of War," so that the people of his own country would remember him. Mrs. Coppini was not in good health and remained in New York. While Coppini worked in Italy, the Academy met and discussed changing the name of the organization. One member, Gene Anderson Woods, was ill but knew of the plans to change the name and had an idea.

She telephoned while the meeting progressed, "Why not credit our founder and call it the Coppini Academy of Fine Arts?"

The members voted unanimously for the suggested name change and cabled Coppini of their decision. When he returned to San Antonio he told them, "I was awakened from my bed at four o'clock in the morning by someone pounding on my door. When I went to the door a man handed me the cable. I was so afraid something terrible had happened to Lizzie, but when I read the message that you had named the Academy after me, I cried like a baby, to think you love me so much to do such a thing. I was very touched."

Although Coppini received many awards and honors throughout his lifetime, Waldine found special pleasure in having been part of that very personal honor the academy members bestowed upon him.

THE END OF AN ERA

X

THE SUN SETS...

ON JANUARY 19, 1952, Waldine's father, after suffering a long illness, passed away at her sister's home. She regretted that his own dreams for success had never materialized, but hoped that through the beauty of her own creations he had found some joy, some satisfaction, some reason for his existence. It wasn't much of a consolation for him, but she prayed it had been enough.

Shortly afterward, having obtained a commission to create an eight-foot statue of the late Dr. Hal F. Buckner, founder of Buckner's Ranch for Boys in Burnet, Texas, she dispelled her grief with hard work. She had never met Dr. Buckner but knew of his dedication to helping young orphaned or abandoned boys, and portraying him came easily. She envisioned him taking one step forward, his arm around a young lad who looks up at him for protection and inspiration, while he looks up to the heavens for his own guidance and inspiration.

She felt a particular parallel between Dr. Buckner helping his boys and those people — her father, the Brady Tuesday Club, and the Coppinis — who had helped and inspired her. Her hands molded the plastilina with respect and humility.

She spent a good deal of her time assisting Coppini, for although he was eighty-four, he was swamped with commissions

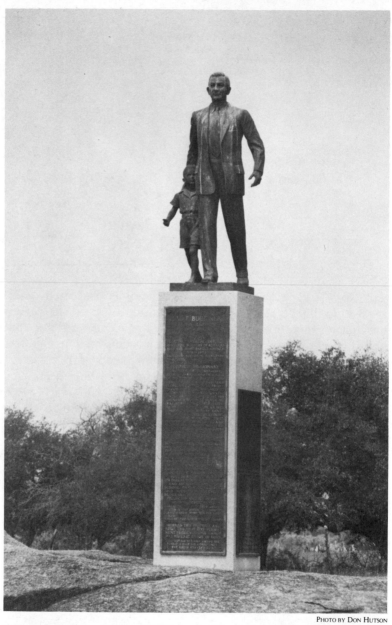

"DR. HAL BUCKNER AND BOY," 1952, AT THE BUCKNER'S RANCH FOR BOYS IN BURNET, TEXAS.

122

and would not refuse a work he felt should be done. Therefore, when Frank Huntress, the publisher of the *San Antonio Express* and *News,* asked him to create a memorial statue of Colonel George W. Brackenridge for a paltry sum of $2,000, Coppini accepted the task because he too admired the late businessman and philanthropist who had donated hundreds of acres for San Antonio's beautiful Brackenridge Park. However, when he finished the clay model there were no funds for casting it into bronze. The statue remained in his studio, pushed back into a corner, out of the way — a dream with no reality, but a dream which would later become a nightmare, not for the master, but for the protégée and for the mayor of San Antonio.

Waldine also assisted Coppini in designing and executing the small sketch for the $100,000 Texas Ranger Memorial for the capitol grounds in Austin. The memorial depicting an early Texas Ranger on horseback and trailing a pack mule would have been Coppini's fourth on the grounds. However, although he won the competition, hard times prevented the state legislature from appropriating funds, so the memorial never became a reality.

Although she assisted Coppini in building the armature and packing it with the initial coating of clay, he considered it a point of professional pride and ethics to do all of the detailed finished work himself. However, she had the same pride in her work and, although she recognized him as the master, zealously prevented even him from adding any finishing touches to her creations. Having attained the rank of a monumental sculptor, her only regret was that because she was a woman, he felt she had gone too far in her career. She loved heroic work and found the exacting, strenuous task to her liking. Through her work she felt in touch with God, as if He were guiding her hands and fulfilling her dreams.

During that time, diabetes and failing health plagued Mother Coppini and confined her to a wheelchair. She required constant care and her meals had to be carefully prepared three times a day. The burden, of course, fell upon Waldine, but she loved the elderly woman and grieved to see her foster mother in pain. Waldine did everything possible to make Mother Cop-

pini's last days as pleasant as possible, including hiring a nurse to help with meals, another act of love, another repayment of a debt she felt she still owed.

While Waldine tended to Mother Coppini, assisted Dr. Coppini, and finished her Buckner, news reached her that the Brady Tuesday Club was raising funds for a statue to be placed in front of the Browning Library at Baylor University in Waco. The library houses the greatest collection of writings and mementoes of the English poets Robert and Elizabeth Barrett Browning and is recognized throughout the world as a shrine to their memory. Since Robert Browning was one of her favorite poets, Waldine was excited about the news and hopeful that she would receive the commission. However, she knew the task of raising funds for art works often took a long time, and just as often plans were abandoned because interest and enthusiasm dwindled. Yet she knew the Tuesday Club had excellent contacts and their plans would probably materialize. She began rereading Browning in her spare time and visualizing each of his poems immortalized in bronze.

When the Daughters of the American Revolution in Austin commissioned Dr. Coppini for a monument of George Washington, he left San Antonio to create his last memorial in his New York studio, but Mrs. Coppini was too ill to travel and remained behind in Waldine's care.

Another commission came her way when her sister-in-law, Grace Tauch, persuaded a friend of hers, Mrs. Louis Kocurek, to have a garden portrait group made of her two young children. Grace discussed it with Waldine and plans were made for its creation as soon as some other commissions were completed. Much of her work came to her in that manner, through friends' and relatives' suggestions or by their knowledge of plans for monument competitions. With her reputation well established, she no longer had to seek out commissions and occasionally turned some down because she was too busy or the project did not inspire her.

Therefore, when a young woman came to discuss acting as her agent, searching out commissions and handling contracts for her — for a fee, of course — Waldine understandably refused. She didn't need such a service. But the woman persist-

ed, attempting to tantalize her with a hint of privileged information about a prestigious commission for Baylor University. Waldine recalled the Brady Tuesday Club's fund raising but said nothing as she escorted the woman to the door.

"I've managed quite well all these years without an agent," she stated firmly. "I certainly don't need one now." She went back to her work, content she would not hear from the young woman again.

However, the agent learned of Waldine's prospects for the garden statue and that a contract had not yet been negotiated, so she boldly contacted Mrs. Kocurek directly, presenting herself as Waldine's agent.

Responding to the agent's presentation, the bewildered Mrs. Kocurek replied, "I don't know what this is all about, but I've been dealing directly with her sister-in-law and unless she tells me otherwise, I will continue to do so."

The agent apparently admitted defeat when Waldine received the Kocurek commission without her assistance and the presumptuous young woman's efforts appeared to be a joke among Grace, Waldine, and Mrs. Kocurek. They laughed and dismissed the woman from their thoughts.

Mary Ann and Tommy Kocurek came to the studio regularly to pose for their statue. Waldine enjoyed working with the children, for they were well behaved and intensely curious about her work. They amused her with their questions and subsequent amazement at her answers. Few people understand the work that goes into a statue, but the Kocurek children seemed determined to learn all the intricacies, and Waldine joyously felt like a teacher once again.

Meanwhile, the Brady Tuesday Club wrote that they had raised half of the $25,000 needed for the Browning Library statue, and Baylor ex-students Mr. and Mrs. John Leddy Jones of Dallas agreed to donate the other half. They asked Waldine to submit her interpretation for a statue from Browning's *Pippa Passes.*

That night before she retired she read the drama once again, then slept with thoughts of the young girl skipping through her dreams. A few hours later she awoke with a start, an image of Pippa in the form of a statue branded on her mind.

Before her idea could escape, she turned on her light and on a scrap of paper quickly drew a rough sketch of her vision. She learned early in her career that the quality of ideas wrought from dreams often surpassed those forced out of her mind in the daytime, but unless she jotted down those ideas immediately, by morning she forgot them, and all that remained was a nagging suspicion that she had had a brilliant idea. When she had no paper, she drew on the floor with charcoal, but in some way she preserved the idea, and the floor could always be cleaned.

In the morning she studied her rough drawing over breakfast and knew the idea was good. She spent the rest of the day drawing finished sketches showing several views with details. As Browning divided Pippa's day into four segments and labeled them "Morning," "Noon," "Evening," and "Night," so Waldine interpreted those segments into four medallions at the rear of the statue of Pippa, whom she portrayed skipping down a street, singing her way through the day. On the base for the statue would be Pippa's immortal words, "God's in His Heaven — All's Right with the World."

According to instructions given her, she submitted her finished drawings for the approval of Dr. A. J. Armstrong, Chairman of Baylor's English Department and founder of the Browning Library. She learned later that when he received her sketches he was so delighted with her conception that he told the Brady Tuesday Club, "I'd rather have this at twice the price than any other submitted. It really catches the Browning spirit."

However, before Waldine began the Pippa, the young woman who wanted to represent Waldine as an artist's agent reappeared to demand her commission for the Pippa. She decided her hint about a prospective statue had directly led the sculptor to seek out the commission. Waldine declared that she had already known about the statue and refused to pay, but the young woman didn't believe her and threatened to sue. Waldine dismissed her, assured she had nothing to worry about.

When the young woman's lawyer called her a few days later, she took the matter seriously and became frantic. Waldine discussed her situation with her own lawyer, and he con-

vinced her that although it was unfair, a court case would take too much of her time and the publicity could possibly damage her fine reputation. Also, he added, she might even lose. He advised her to try to settle out of court for one thousand dollars, about half what the woman was asking. But a thousand dollars was a lot of money to give someone for doing absolutely nothing, and although she agreed to pay so she wouldn't be tied up in a courtroom for weeks, she was so angry and frustrated at the injustice that she was unable to concentrate on her work.

After she appeared with her lawyer and negotiated the settlement, she sighed in relief that at least the matter was finished. However, the full impact of the woman's perseverance and audacity astounded even the two lawyers when the woman approached Waldine.

"Now that that's settled, Waldine, why don't I meet you at your studio so we can talk business?"

Waldine stared in disbelief, then not knowing whether to laugh or cry, walked abruptly away without a word.

With her legal problems solved and her anger subdued, she began her search for the perfect model for Pippa and delighted in finding a fourteen-year-old Italian girl who, like Pippa, was a factory worker. After she built the armature, Waldine's skillful hands shaped the graceful figure of Pippa, and as the song of Pippa filled her soul with contentment, she knew that for her, too, all was right with the world.

On Sunday afternoon, May 27, 1956, Waldine attended as an honored guest the unveiling ceremony for the bronze Kocurek Garden Portrait. Leopold LaFosse directed a string quintet in musical interludes throughout the afternoon to entertain the wealthy guests, who numbered over four hundred. Artist Amy Freeman Lee formally introduced Waldine to the gathering before the children, Mary Ann and Thomas Michael, unveiled the statue, which was then blessed by the Right Reverend James M. Boyle. The ceremony was the most beautiful and dignified private unveiling Waldine had ever attended.

While she continued her work on Pippa, Dr. Coppini returned from New York, having finished his George Washington. Waldine was startled to see how old he had become, for

127

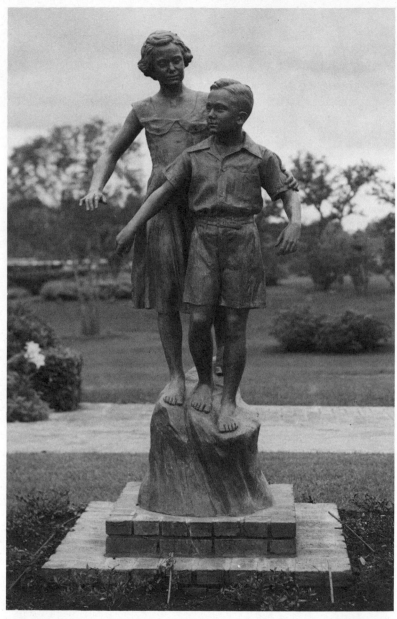

GARDEN PORTRAIT OF MARY ANN AND THOMAS MICHAEL KOCUREK," 1955, THE
CHILDREN OF MR. AND MRS. LOUIS KOCUREK, SR. AT THEIR HOME IN SAN ANTONIO,
TEXAS.

his face sagged along with his shoulders and he moved about slowly. Mrs. Coppini, though practically bedridden, rarely complained, and Waldine enjoyed caring for her, not minding the time she spent preparing Mrs. Coppini's meals and nursing her. Dr. Coppini, on the other hand, had always been robust and often argumentative. His declining health made him more cantankerous and, for the first time in his life, somewhat helpless. He worried about his New York studio and finally sent Waldine to attend to its sale, admitting to himself that he would no longer have use for it.

Finishing her work on the Pippa, Waldine flew to New York to talk to the realtor and to clean up the studio so it could be easily sold. When he took her to the building she was shocked at its condition, for apparently the caretaker's dog had been left inside for long periods of time. The stench nauseated her, and the realtor, feeling sympathetic, bought her a bouquet of red roses and took her out to dinner.

The next day several friends, including the caster, Cesare Contini, helped her with the task of cleaning the filthy studio and packing the many small statues and sketches left behind by Dr. Coppini. After several weeks the studio was sold, and Waldine returned to San Antonio to nurse her foster parents.

Dr. Coppini's health rapidly declined, and when his bowels locked he was rushed to the hospital. The doctors ran several tests, while Coppini gave the staff a hard time and begged to be sent home. Finally, as the doctors could find no cure for him, he was released with the nurses' blessings. However, at home he became violently ill and was forced to return to the hospital. Apparently aware that he was in his final moments, he called for Waldine.

"My dear," he said, "I must tell you something. In those early years when I made you tear apart your nearly perfect works, I did it because I had to see if you had what it takes to be a great sculptor, and you did. You've been a wonderful daughter."

A week later, on September 27, 1957, he passed away at the age of eighty-seven.

Mother Coppini, broken-hearted, lost her will to fight her own illnesses and died only a few months later.

Waldine was philosophical about the Coppinis' deaths, for they had each lived full, productive lives. She had many friends to console her and too much work to spend time in grief; the Coppinis would not have wanted that. One era of her life ended, but another, perhaps even more exciting than the first, was about to begin.

XI

...AND RISES

THE DAY after Dr. Coppini's funeral, the Coppini Academy chartered a bus and accompanied Waldine to the impressive unveiling ceremonies of her "Pippa Passes" at Baylor. Dr. Armstrong, who had instigated the project, had passed away before seeing the finished Pippa, and in his honor the library was renamed the Armstrong-Browning Library. Governor Price Daniel, himself an ex-student of Baylor, spoke to the more than one thousand people in attendance, and Mrs. S. W. Hughes, the only living charter member of the Brady Tuesday Club, presented the statue and introduced its creator, who received an extended ovation. The trip and being surrounded by friends helped ease Waldine's grief.

Waldine inherited the home and studio of Dr. Coppini with the stipulation that the second floor be used as an art gallery. She intended to keep the Academy active and through her sponsorship succeeded in scheduling exhibits at museums throughout Texas, including the Witte, which at that time concentrated its efforts on classical fine arts rather than abstract or modern art. Often she hauled the members' exhibits herself to cities and towns throughout Texas, usually accompanied by Belle and Erwin Wesp, two dedicated and hard-working members of the Academy.

131

Song from *Pippa Passes*

by Robert Browning

The year's at the spring
And day's at the morn;
Morning's at seven;
The hill-side's dew pearled;
The lark's on the wing;
The snail's on the thorn:
God's in His heaven —
All's right with the world!

This is the song Pippa sings as she skips through the streets of Asolo on the one and only holiday she receives through the year, New Year's Day. She thinks about those people in the town who seem to be the most happy, not knowing they suffer from the evil in their hearts. However, as the day progresses, each of the people see Pippa skipping and hear her song, and her goodness dissipates their evil. The sculptor portrays four medallions of the four couples at the moment of transformation from Evil to Good; Pippa, as an ultra-relief, reflects the Power of Good.

"PIPPA PASSES," 1956, BRONZE LIFE-SIZE ULTRA-RELIEF AT BAYLOR UNIVERSITY IN WACO.

GOD'S IN HIS HEAVEN — ALL'S RIGHT WITH THE WORLD!

PHOTO BY WINDY DRUM

133

When various civic and university groups invited her to lecture, she enthusiastically expounded her ideal, which had also been Coppini's, for as surely as he had shaped his monuments he had also shaped and molded her mind.

An article by Sir Winston Churchill, actually an excerpt from his book, *Painting as a Pastime,* appeared in an American magazine, and since his ideals were consistent with Waldine's and the Academy's, she encouraged the current Academy president, Erwin Wesp, to write Churchill requesting his consent to become an honorary member.

When Churchill accepted the honor, commenting that he considered it a high compliment, Joy Carrington designed and executed the certificate on Roman vellum paper, topped with an illustration of the Alamo and bordered with paintings of bluebonnets and Indian paintbrushes.

In 1959, Earle Wyatt, the cafeteria entrepreneur, donated $25,000 to the Dallas Historical Monuments Commission. He wanted a statue of a modern Texas Ranger placed in the terminal of Love Field to welcome visitors and returning Texans. The Commission immediately announced the open competition, and Waldine returned to her history books. Her compulsion for authenticity led her to Waco, Temple, and Austin in search of a real Texas Ranger for her model.

She met many Rangers but was uninspired until the Austin Rangers showed her a scrapbook filled with news clippings of Ranger activities. Throughout the book she noticed that one Ranger's name stood out above the rest: Captain Jay Banks of Dallas. She decided Captain Banks was the one Ranger perfect for her project. The Rangers in Austin cooperated by setting up an appointment, and she traveled eagerly to Dallas to meet the controversial Ranger. She knew at once when she saw him that his manly appearance would perfectly portray her ideal, and after a lengthy interview she was thrilled to discover that his character matched his colorful past. With reluctance he agreed to go to San Antonio to pose for her statue, for posing didn't seem manly to him.

Hal Perkinson of Dallas, the man in charge of publicity for the Rangers, accompanied Banks to her studio, where they stayed for nearly two weeks while she took measurements and

photographs and did some initial sculpturing. Since one of the regulations from the Commission specified that the Ranger statue should not resemble any one Ranger but be a composite of all Rangers, she took care to change a few minor features, but she was sure that those who knew Captain Banks would still recognize him.

Another specification was that the Ranger not have his hand on his gun, but poised over it to give a criminal a chance to draw first. She depicted her Ranger with boots, cowboy hat, engraved leather holster, and guns, which Captain Banks brought with him and left in her possession to copy. As her Ranger steps forth, his hand is ready to reach for his gun in an effort to keep law and order. She won the commission and spent the next eight months building the eight-foot armature and creating the statue from his "skeleton," then from the nude model.

"Oh, no!" Waldine exclaimed emphatically to an inquirer, "Captain Banks certainly did not pose for the nude figure." But at one time, even the proud and dignified "Texas Ranger of Today" stood tall and naked in her studio.

Banks proclaimed when he finished posing, "It's hard work, but it did me some good, posing for the statue. Until I did, I always thought models were sissies."

She completed her clay statue near the end of 1960, and Ray Hubbard, chairman of the Dallas Park Board and member of the Commission, announced the statue's acceptance. She then sent for her good friend and caster from New York, Cesare Contini, to come to San Antonio to cast the statue into a plaster of paris mold.

Cesare descended from a line of Italians famous for making casts of sculptors' clay statues and had cast the majority of works done for the Texas Centennial, not only those by Waldine and Coppini but by many other artists too. Waldine knew of no one in Texas to whom she could entrust the job of casting. An inexperienced caster could ruin and even demolish a work which took over a year, sometimes longer, to complete. With Cesare she knew her statue would not be harmed.

On Sunday afternoon, April 30, 1961, the eight-foot tall "Texas Ranger of Today" was unveiled by Miss Mary

135

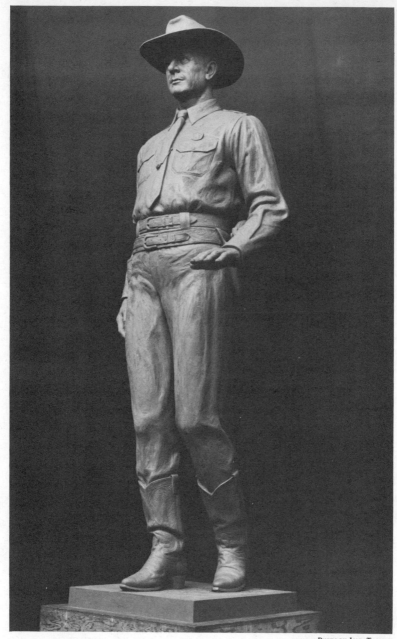

PHOTO BY JOHN TARSIKES

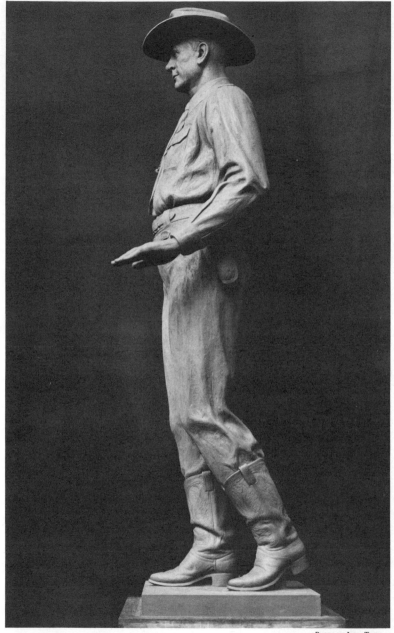

PHOTO BY JOHN TARSIKES

"TEXAS RANGER OF TODAY," 1960, FOR LOVE FIELD IN DALLAS, TEXAS. THE STATUE NOW STANDS IN THE UNION TERMINAL OF THE NEW TRANSPORTATION BUILDING IN DALLAS.

137

WALDINE CLIMBS TALL LADDERS AND WALKS ACROSS SCAFFOLDS TO REACH THE TOP OF THE EIGHT-FOOT ARMATURE OF THE ''TEXAS RANGER OF TODAY.'' SHE NAILS SMALL STRIPS OF WOOD LATH, BUILDING THE SKELETAL SHAPE ON WHICH SHE WILL LATER APPLY THE CLAY.

138

Carolyn Hall, Earle Wyatt's niece. The city fathers of Dallas had arranged a magnificent ceremony with Mayor Thornton reserving the event as his last official act. Coincidentally (or otherwise), that weekend a company meeting of Rangers was held in Dallas, so although it purportedly takes only one Ranger for one riot, it took sixteen for one unveiling. "Just showoff," explained Ranger Captain Bob Crowder with a grin.

For years the statue welcomed and impressed visitors to Dallas, including Alistair Cooke, who wrote of the statue and the Ranger in 1961, "[He] has shoulders like the Parthenon, and leans very slightly forward, not (heaven forbid) from fear but from his God-given instinct to smell an Indian . . . on the down wind at 30 miles."

Later, when the Dallas-Fort Worth Regional Airport opened for business in 1974, the Ranger was temporarily retired. Several organizations, including the Ranger Baseball Club, a museum, and a college tried to negotiate for it, but Wyatt, before his death, requested that the statue remain in Dallas. At the Union Terminal, a landmark building completed in 1978 as part of the new Transportation Center, the Ranger has his new home.

While working long hours on the Texas Ranger, Waldine took time out to receive a Headliner Award and granted journalist Helen Reagan interviews for a story in the national magazine *Success Unlimited.* She supervised workmen remodeling the upstairs of the new addition for the new art gallery, and just before she completed her Ranger she took a proud part in the opening ceremonies of the Coppini Memorial Gallery.

After the unveiling of the Ranger, the world-famous National Cowboy Hall of Fame nominated her to its hall for her dedicated work in preserving the memory of the Ranger and for a bust of Harry Jersig, philanthropist and president of Lone Star Brewery. However, she was not elected.

She continued receiving commissions for heroic-sized works regularly, as if without Coppini casting his long shadow, her creativity and energy soared freely to new heights of accomplishment. She was no longer the student, but at last the mentor. When asked her age, she stated firmly, "Thirty-nine, now and forever." Some thought her remark was vanity, but

139

actually she knew through her keen business instinct that no one would give her a commission if they knew her age.

"They'd think I was too old to handle the job, or worse yet, that I'd die before I finished."

Works in various stages of progress filled her studio, and she felt obliged to complete each one while continuing to accept new commissions. Filled with energy and determination, she found no time nor desire to retire, ever.

XII

NEW HORIZONS

IN 1964 the National Sculpture Society of New York City honored Waldine by electing her a Fellow to their prestigious organization. She was the only one of four nominees to receive the high honor that year.

Meanwhile, the Douglas MacArthur Academy of Freedom was established on the Howard Payne College campus in 1962 to offer a four-year course in diplomatic and governmental service. The building was open to the public to focus the thoughts and actions of Americans of all ages toward a deeper love and appreciation of the meaning of the American way of life. A desire for a statue prompted Governor John Connally to proclaim officially the week of November 8, 1964, to be the Douglas MacArthur Academy of Freedom Week throughout Texas. Students in high schools, junior high schools, and elementary schools jointly and separately conducted campaigns to raise funds for a memorial statue of the late general to be placed at the Academy. As usual, Waldine didn't wait for the competition to be announced but immediately began researching the life of MacArthur so she would be well prepared when the competition was announced.

She competed for and won competitions for two large works: the first for a nine-foot tall bronze of the late mayor of

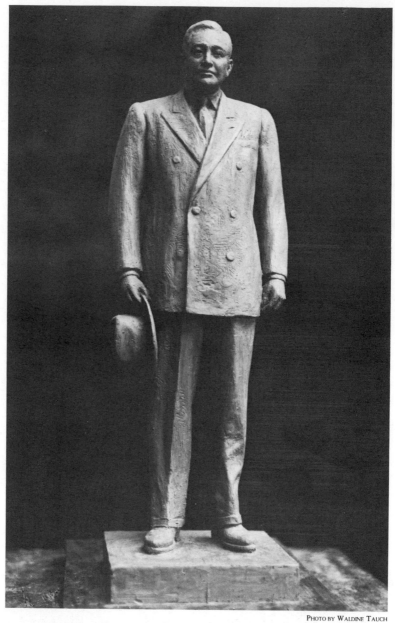

Photo by Waldine Tauch

"R. L. Thornton," 1966, for the State Fairgrounds in Dallas, Texas.

142

Dallas, R. L. Thornton, who was largely responsible for bringing the 1936 Centennial Exposition to Dallas. The cost of the work was $75,000, and it was unveiled on the State Fairgrounds on New Year's Day in 1968. His daughter, Katherine Thornton Holt, wrote of the finished statue: "[I] loved the robust figure that was my father in younger and more vigorous years. Thank you for getting the likeness."

Waldine's second commission was for an "ideal of education" for a fountain in front of the Chapman Graduate Center at Trinity University. She artistically interpreted a youthful, muscular, and semi-nude man sitting on a bench, reading from the Book of Knowledge which sits upon his knees. His other hand holds the Torch of Enlightenment above a sculptured world. She titled her ideal "Higher Education Reflects Responsibility to the World." She made his expression strong and determined, yet also meditative. When her principal model was unavailable to pose, two Trinity University students substituted, so that the finished statue is actually a composite of three people.

The donation for the statue came from Dr. Andrew G. Cowles and his late wife, Ruth Elizabeth, the daughter of Mr. and Mrs. P. S. Chapman, for whom the Chapman Graduate Center was named.

While Waldine toiled happily with her creations, her studio filled with the plaster originals which were usually returned to her after the bronze casting. Many of them she placed on exhibit at the Panhandle Plains Historical Museum in Canyon, Texas, and then she promptly forgot about them. However, when Boone McClure, the director and her good friend, wrote asking her when she wanted the works returned, she found herself in a quandary. She had no room for them in the studio and actually didn't want them back at all. What could she do? She suddenly hit upon the perfect solution! She wrote to Boone McClure:

> The works of sculpture you have in your museum created by Dr. Coppini and also those done by myself were placed there as a loan. But, I have decided to give them outright, with no strings attached.

143

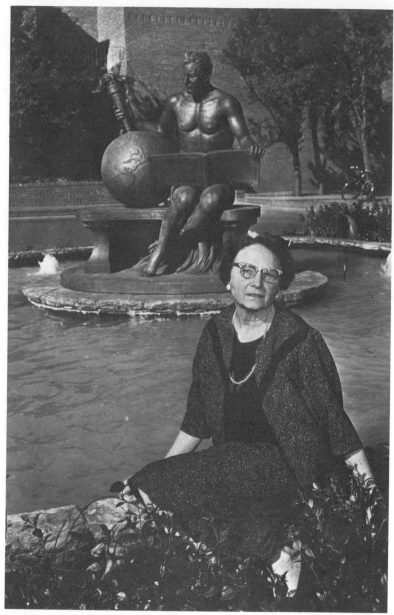

Waldine poses in front of her bronze statue, "Higher Education Reflects Responsibility to the World," 1965, in front of the Chapman Graduate Center of Trinity University in San Antonio.

144

The statues would have a good home and she would never have to worry about them again. Delighted with that bit of ingenuity, she added to her donation a check for one thousand dollars. The minimum value placed on the sculptures was over $70,000 and included her "Pippa Passes," "Texas Ranger of Today," "Dr. Hal Buckner," and other smaller works. Among Coppini's works was the original design of the front and reverse side of the Texas Centennial half-dollar issued in 1936.

In 1966 the city of San Antonio established a Fine Arts Commission, appointing eleven professional members to offer the council its judgments on matters concerning city plazas, bridges, landscape design on city properties, art work, sculpture, and architecture. Waldine was one of the members appointed to serve a three-year term, and she attended meetings regularly. However, the council members often seemed to forget they had formed the Fine Arts Commission. The council accepted art objects without even the knowledge of the FAC, and a communications problem existed from the inception of the new commission which would later cause quite a disturbance.

Meanwhile, funds for the Douglas MacArthur statue were obtained, and one afternoon Waldine received a telephone call from Dr. Guy Newman, president of Howard Payne College, which would climax her lifelong career.

"Dr. Tauch, we have the money now, and we want you to do the Douglas MacArthur statue for us. Will you?"

Excited and amazed that she would not even have to compete for the commission she most wanted, she breathlessly answered, "Why, of course, I'll do it. And I promise you this one will be my masterpiece, for I have long been an admirer of the general."

Although she had read everything written about MacArthur, Waldine returned to her books and also began an extensive search for photographs. Major General William C. Chase, retired, of Houston, assisted her in gathering all sorts of materials, including a full report of his Army physical examinations from which she learned his accurate weight and height and some of his other body measurements. Mrs. MacArthur furnished her his uniform, and the MacArthur Memorial

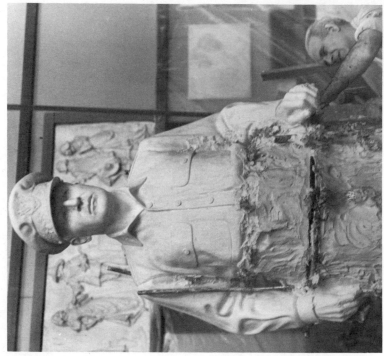

AFTER THE MOLD IS MADE AND THE PLASTER POURED INTO IT AND HARDENED, THE CASTER CAREFULLY CHIPS THE MOLD OFF THE PLASTER STATUE.

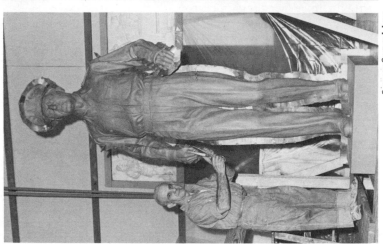

CASTER CESARE CONTINI INSERTS METAL SHIMS INTO THE CLAY AS A FIRST STEP IN THE CASTING PROCESS.

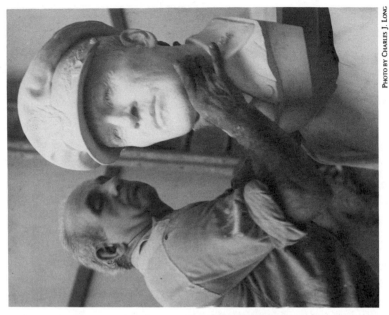

PHOTO BY CHARLES J. LONG

THE PLASTER OF PARIS STATUE IS MADE BY CONTINI'S UNIQUE METHOD TO COME APART IN WHAT IS CALLED ROMAN JOINTS SO THAT CRATING AND SHIPPING THE WORK IS SIMPLER AND SAFER.

PHOTO BY CHARLES J. LONG

WITH THE USE OF A CRANE, THE CASTER CAREFULLY LOWERS PART OF THE PLASTER "DOUGLAS MACARTHUR," WHICH FITS LIKE A PIECE OF A PUZZLE INTO ITS BASE.

147

Foundation in Norfolk, Virginia, sent his cap, from which she was able to determine his head measurement.

When she finished her meticulously thorough research, she drew pictures of the general in various poses, finally deciding to depict him as he strode ashore at Leyte on his return to the Philippines on October 20, 1944. She submitted her finished drawings, showing all views, to the seven-member committee and upon their approval began creating the sixteen-inch clay model.

In March of 1966 two members of the committee, Mrs. Dallas B. Sherman of New York City and Major General Chase, visited her at her studio to view and inspect her sketch. They were both delighted with the results and told her to go ahead with the full-sized eight-foot statue. No changes had to be made. Her research had paid off.

Waldine began building the huge armature of pipes and wood, climbing ladders that were dangerously high and precariously perched above the concrete floor of the studio. For nearly two years she labored with the weight of the plastilina clay, placing a heavy burden upon her body. But whenever her burning, aching muscles screamed for mercy, she recalled the days of her youth, remembering that the work wasn't easy then either. No matter how weary she became, she never considered quitting, never excused herself because of her age, and at moments of intense concentration she even succeeded in ignoring her pain.

When she finished the statue, satisfied with every detail of its uniform and cap, she wrote to the committee. Most of the members had known MacArthur personally and some had even walked with him up the Bay of Leyte. When they arrived she was as nervous as a beginner, so much did she want their approval, and she knew they would be her most critical observers. She guided them to the studio entrance, then allowed them privacy as she waited alone in her office for their remarks. Pacing the floor, she grew more anxious as she heard no sound from the other side of the door. She jumped when she heard Major General Chase's voice boom.

"That's the general!" he exclaimed, and the others agreed more quietly. Her worry was over and she joined the committee, accepting their praises with a sigh of relief.

However, her relief was short-lived, for a moment later one member noticed something was missing. Waldine's heart sank, knowing that any change at that point could involve weeks or even months of extra work.

"*What* is missing?" she asked in despair, not quite wanting to know.

"His West Point ring! He always wore it. It wouldn't be right if he didn't wear it now."

"Oh, is that all? Well, if you can get his ring for me, or one like it, I can fix that in a hurry," she responded almost gleefully, knowing that she could remedy the situation in a short time and glad, too, that the missing ring was discovered before the statue was cast in plaster of paris, or worse — in bronze.

A friend obtained a West Point ring and Waldine added that final touch to the statue, then contacted Cesare Contini to come to San Antonio to cast her statue as soon as possible, for the Academy wanted it in time for the opening ceremonies of the new building.

However, the statue took three weeks to cast in plaster of paris, and it was not until the end of 1968, over two years after Dr. Newman's telephone call, that the statue was ready to be shipped to the bronze foundry in Italy to be cast into bronze. The MacArthur was delayed by a longshoremen's strike in Italy when it arrived, then once again laid waiting in the hold of a ship in Houston's port because of another strike. Only two weeks before the scheduled unveiling ceremony did the statue arrive in Brownwood to be mounted on the green marble base designed by Frank Dill, architect of the new building, in front of the MacArthur Academy of Freedom.

Later, Waldine's sixteen-inch model was also cast in bronze and displayed permanently at the MacArthur Memorial Foundation in Norfolk, Virginia.

When her MacArthur was unveiled in the spectacular ceremony, she told reporters with her usual zest, "It's been a good world. In fact, I'm enjoying it more now than when I was younger, because I know it better."

She had learned early in her career that there was not always money available to carry out some of the most worthy

ideas, but that quite often determination could conquer such problems. Such was the case when the city of San Antonio in 1966 began planning HemisFair, an elaborate world's fair for 1968. Much money would be received from the federal government under an urban-renewal grant, and many women's organizations envisioned a building set aside to display women's accomplishments. Waldine liked the idea and thought it would make a fine showcase for her own works. However, when the idea was presented to the City Council they discovered no money was available for such a project.

Undaunted, Waldine invited several of her lady friends, some wealthy, some socially prominent, to her home for tea, telling them of the women's idea for a Woman's Pavilion. She won their wholehearted approval, then audaciously requested each of them to donate five dollars to the building fund and to solicit another five dollars from ten of their own friends. She fully realized that mere five-dollar donations would never amount to enough for the building, but she hoped one or two of the rich ladies would donate a much larger sum. The fund raising was started, and women's organizations throughout the city contributed, as did many private individuals. The Woman's Pavilion became a reality, and Waldine was represented there as well as in the Italian Pavilion alongside Coppini.

That summer HemisFair successfully opened and brought millions of tourists to San Antonio, and while Waldine was finishing her MacArthur, the wheels of her mind were grinding at new ideas. In her last year as a member of the Fine Arts Commission she wanted to accomplish something of lasting value. Eyeing the huge plaster model of Coppini's Brackenridge, she had an idea.

She made an appointment with Mayor Walter W. McAllister and told him her idea of having the model cast in bronze. The mayor, having known Brackenridge and being aware of his vast contributions to the city, also thought the philanthropist should be immortalized in bronze and encouraged her to proceed with plans. Pleased with his reaction, at the July 1968 Fine Arts Commission meeting she informed the group, "The city wants to cast in bronze a monument of Colonel Brackenridge which was originally done by Coppini. I

understand it will be placed in a new entrance to Brackenridge Park at Funston Place.''

The Commission asked for photographs and sketches of the proposal for the next meeting, whereupon the FAC voted unanimously to recommend that the city have it cast in bronze and promptly appointed a committee to study recommendations for its placement. Waldine signed the contract for the work and sent it to City Hall for council signatures, then carefully crated the model and shipped it to the Italian foundry to be cast.

Meanwhile, she busied herself with creating a plaque of the late president of the University of Texas, John W. Calhoun, for the Calhoun Hall.

In the spring of 1969 the Texas Senate rewarded Waldine's many efforts by citing her publicly for her patriotism, her sculptures of famous figures in Texas history, and her outstanding contributions to the cultural enrichment of the state of Texas. The Senate honored only one other artist that year, Reveau Bassett of Dallas. Their awards were presented to them by Lieutenant Governor Ben Barnes.

In July the city of San Antonio also gave her a citation of honor — one month before the bronze statue of George Brackenridge arrived at the City Parks Department, unannounced and unexpected.

Communications between the City Council and its own appointed Fine Arts Commission had never been good, but it was never more embarrassingly evident than on August 27, 1969, when councilmen learned for the first time through local newspapers that a bronze statue was delivered to the city. The contract Waldine had signed and forwarded to the city had never been signed by city officials, for the mayor had neglected to put the proposal before the council for a vote. There was no official authorization for the statue. Yet, the city had the statue and a bill for $30,000, and someone had to pay it.

The following day the Council met, and Mayor McAllister attempted to smooth ruffled feathers by explaining that the $30,000 would be raised by private citizens and the city would only have to pay for the cost of the base.

Councilman Pete Torres was not appeased and retorted, ''I think that it would be wonderful if we could afford ten

"Dick Prassel," 1966, bas-relief set in granite and located at Prassel Manufacturing Company in San Antonio.

152

The text on the bas-relief reads:

FRANCES HELLUMS HUDSPETH

1907 1972

WHOSE LONG SERVICE TO THE UNIVERSITY
COMMUNITY WAS FILLED WITH STEADFAST
DEVOTION AND COMPLETE UNSELFISHNESS

AUTHORIZED BY THE BOARD OF REGENTS
THE UNIVERSITY OF TEXAS SYSTEM, 1972

"FRANCES HELLUMS HUDSPETH," BAS-RELIEF DONE IN THE EARLY 1970S FOR THE HARRY RANSOM CENTER AT THE UNIVERSITY OF TEXAS IN AUSTIN.

153

"JOHN WILLIAM CALHOUN," 1968, BAS-RELIEF FOR THE CALHOUN BUILDING AT THE UNIVERSITY OF TEXAS IN AUSTIN.

154

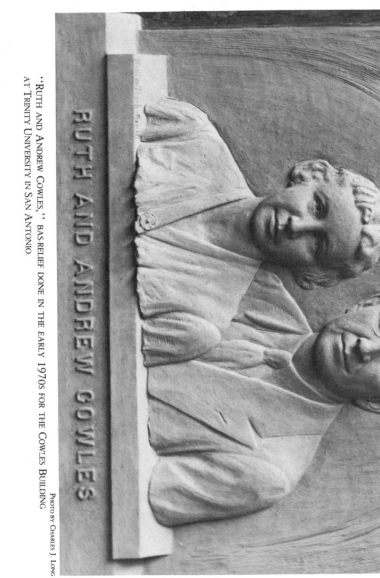

RUTH AND ANDREW COWLES

"RUTH AND ANDREW COWLES," BAS-RELIEF DONE IN THE EARLY 1970s FOR THE COWLES BUILDING AT TRINITY UNIVERSITY IN SAN ANTONIO.

PHOTO BY CHARLES J. LONG

155

bronze statues of Colonel Brackenridge. I am sure he is [*sic*] a wonderful man, but . . . we have many, many other needs in the city and apparently authorization was given either by you, Mr. Mayor, or somebody else.''

Torres made further remarks implying that something seemed underhanded about paying a member of their own commission for work they had not even authorized. McAllister reiterated that private citizens would be paying the $30,000, but Torres seemed not to hear. Both men were angry beyond reason when Mayor Pro-tem Lila Cockrell intervened with a lengthy explanation of the funds which were raised nearly twenty years earlier and a reinforcement of McAllister's contention that citizens would raise the remainder of the necessary funds to pay the $30,000 bill.

Her clear, melodious voice instilled a calm within the council chambers, and when she finished speaking McAllister attempted to move the council on to other business, but Torres refused to be sidetracked.

''This matter on the statue is *not* closed,'' he warned, and for months the newspapers played up the rift among councilmen about the mysterious arrival of the bronze statue; Waldine worried over the huge bill, which she certainly could not afford to pay out of her pocket; and Mayor McAllister continued to assure her she would not while he busied himself securing donations to pay for the statue. By October 16 he received sufficient monies to advise the council that private subscriptions to pay for the Brackenridge statue had been raised and Dr. Tauch would send a bill of sale to the city.

However, it was not until the January 15, 1970, council meeting that the ordinance to accept the statue passed council vote, with only councilman Torres voting against it. His dissatisfaction arose because McAllister refused to submit a list of donors. Nevertheless, Waldine won her battle, and the disputed Colonel was unveiled on Broadway across from Funston Place in a quiet ceremony on November 14.

That same year she received the commission for the life-size Doughboy which would stand before the American Legion Building in Austin and began constructing the giant armature of wood and pipe. She had other, smaller commissions on

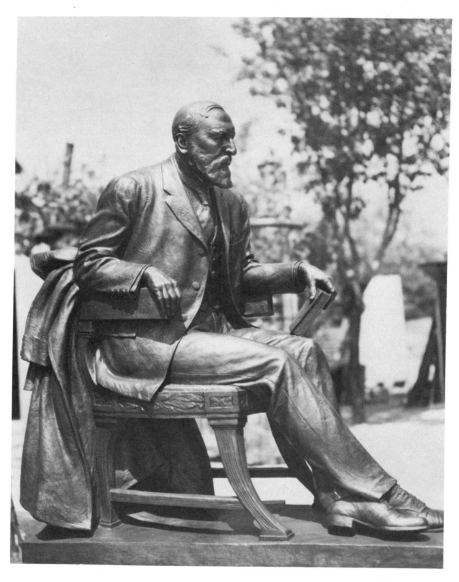

Coppini's bronze "Colonel Brackenridge" surprised city fathers when it arrived unannounced and unexpected at the City Parks Department.

157

which she worked simultaneously, and her whirlwind social life filled her days with exhibits, lectures, civic and art organizations, visits to and from friends, and accepting prestigious awards and honors, such as the National Award for Distinguished Woman of the Year in Art from Alpha Delta Kappa in New York; a citation of honor from the American Legion for her work on the Doughboy; the Distinguished Service Award of the Council of Artists Societies given her by Frank C. Wright, Jr., of New York City. She is continuously listed in *Who's Who* and appeared in the Bicentennial Edition of *Personalities of the South.*

Never forgetting the helping hand she had received as a youth which made her exciting career possible, she extends her own hand in encouragement to youth and to older artists around her as well. Her money supports the buildings of the Coppini Academy, and often she envisions adding a school of fine art to the Academy so young people may be directed away from abstract art and toward the classical art to which she has devoted her life. A seemingly ageless woman, she still has visions of the future, ideas to contribute, and enthusiasm to share.

Waldine Tauch finds all around her the beauty her father sought — often it is beauty which she creates with her own two hands, the contentment which eluded her mother, and the fame which Coppini enjoyed and which now is hers in all its monumental glory. She is well loved and her friends are too numerous to be named, for as she says, "It seems that all the world is my friend." She has come a long way from the chalk figure of an ivory bookmark — all the way from chalk to bronze.

APPENDIX

The Major Sculptures of Waldine Tauch
Listed by City

AUSTIN, TEXAS

John William Calhoun, bronze bas-relief, 1968, unveiled December 13, 1969, in Calhoun Hall, University of Texas.

Doughboy, bronze life-size statue, 1970, unveiled October 9, 1971, in front of the American Legion Building.

Frances Hellums Hudspeth, bronze bas-relief, *circa* 1972, in the lobby of the Harry Ransom Center, University of Texas.

BEDFORD, INDIANA

Indiana War Memorial, 14' statue of Bedford limestone, 1926, in front of Lawrence County Courthouse.

BRADY, TEXAS

Gulf Breeze, 18" bronze statuette, 1930, not commissioned, given to Mrs. W. N. White as token of appreciation from Dr. Tauch, presently in possession of her niece, Oma Willoughby Jones.

BROWNWOOD, TEXAS

Douglas MacArthur, 8' bronze statue, 1966–68, unveiled October 1969, in front of the Douglas MacArthur Academy of Freedom on the Howard Payne University campus.

Mrs. I. J. Rice Memorial, bronze bas-relief, 1911, in the Brownwood Public Library.

J. A. Walker, bronze bas-relief, 1945, unveiled in 1946, in the Walker Memorial Library on the Howard Payne University campus.

BURNET, TEXAS

Dr. Hal F. Buckner and Boy, 8′ bronze statue, 1952, unveiled 1954, at the entrance to the Buckner's Ranch for Boys.

CANTON, TEXAS

Isaac and Frances C. Lipscomb Van Zandt, life-size bronze high-relief, 1938, on the Courthouse Square.

CANYON, TEXAS

Dr. Hal F. Buckner and Boy, 8′ plaster statue, 1952, in the Panhandle-Plains Historical Museum.

Henderson Memorial, life-size plaster high-relief, 1919, in the Panhandle-Plains Historical Museum.

Higher Education Reflects Responsibility to the World, plaster heroic-size statue, 1965, in the Panhandle-Plains Historical Museum.

Pippa Passes, plaster life-size ultra-relief, 1956, in the Panhandle-Plains Historical Museum.

Mrs. Joseph Emerson Smith, small plaster head, 1915, in the Panhandle Plains Historical Museum.

Texas Ranger of Today, 8′ plaster statue, 1960, in the Panhandle-Plains Historical Museum.

J. A. Walker, plaster bas-relief, 1945, in the Panhandle-Plains Historical Museum.

COMFORT, TEXAS

Ernst Altgelt, bronze bust, 1970, unveiled July 3, 1971, at Comfort Park.

DALLAS, TEXAS

Texas Ranger of Today, 8′ bronze statue, 1960, unveiled April 30, 1961, at Love Field, presently located in the Union Terminal Building of the New Transportation Center.

R. L. Thornton, 9′ bronze statue, 1966, unveiled January 1, 1968, on the State Fairgrounds.

160

GONZALES, TEXAS

First Shot Fired for Texas Independence, life-size bronze bas-relief set in granite, 1935, unveiled November 11, 1936, dedicated March 1937, seven miles southwest of Gonzales, near the site of the original battlefield.

JERSEY CITY, NEW JERSEY

Children Reading, bronze bas-relief, 1929, in the Children's Reading Room of the Jersey City Public Library.

MOUNT VERNON, NEW YORK

Washington Speaks for Himself, bronze bas-relief, *circa* 1931, in the Mount Vernon Junior High School.

NEW YORK, NEW YORK

Death Takes Hope, 18″ plaster statuette, not commissioned, 1932, located at the Contini Studio.

Spring Brings Bluebonnets to Texas, bronze statuette, not commissioned, 1936, presented to Mrs. Travis Johnson, a member of the New York Texas Club.

NORFOLK, VIRGINIA

Douglas MacArthur, 16″ bronze statuette, made from model used for the 8′ statue in Brownwood, donated to and located at the MacArthur Memorial Foundation.

OKLAHOMA CITY, OKLAHOMA

Harry Jersig, bronze bust, *circa* 1968, at the National Cowboy Hall of Fame.

PELHAM MANOR, NEW YORK

Smith Garden Portrait Fountain, bronze life-size figures of Smith children, 1928, unveiled 1929, at the estate of Mr. and Mrs. LeSueur G. Smith.

RICHMOND, KENTUCKY

Mrs. F. W. Henderson Memorial, life-size marble high-relief, 1919, placed over Mrs. Henderson's grave.

SAN ANTONIO, TEXAS

Moses Austin, 10' bronze statue, 1937–38, unveiled May 15, 1939, on City Hall Square.

Angel Baptismal Fount, bronze statue, 1928, for Grace Lutheran Church.

Baptismal Fount, life-size bronze of three babies (her nephews), 1962, unveiled October 30, 1962, at Los Angeles Heights Methodist Church.

Boy and the Eel, 17" bronze statuette, not commissioned, 1924, in studio on Melrose Place and in many private collections.

Bronze Dog, life-size statuette of Chihuahua, 1940, presented by friends to dog's owner, Mr. H. P. Rine.

Clinging to Youth, 23" plaster statuette, 1945, at studio on Melrose Place.

Pompeo Coppini, bronze bust, 1930, located at Witte Memorial Museum and at Coppini Memorial Gallery on Melrose Place.

Mrs. Pompeo Coppini, small bronze bust, 1930, at studio on Melrose Place.

Ruth and Andrew Cowles, bronze bas-relief, *circa* 1970, in the Cowles Building at Trinity University.

First Inhabitant, life-size ultra-relief in imitation stone, 1914, on Commerce Street bridge overlooking the San Antonio River.

Genius of Music, life-size bronze statue, jointly produced by Coppini and Tauch, *circa* 1946, for the grounds of the Tuesday Musical Club.

Gulf Breeze, 18" bronze statuette, 1930, not commissioned, at the Witte Memorial Museum and in many private collections.

Mrs. Eli Hertzberg, bronze bust, 1929, at the Tuesday Musical Club.

Higher Education Reflects Responsibility to the World, bronze heroic-size statue, 1965, in fountain in front of the Chapman Graduate Center at Trinity University.

Innocence, the Ideal Head, small bronze head, 1930, not commissioned, at studio on Melrose Place and at Woman's Club.

Harry Jersig, life-size three-quarter bronze figure, *circa* 1968, for the atrium passageway at main office of Lone Star Brewery.

Mary Ann and Thomas Michael Kocurek, life-size bronze garden portrait fountain, 1955, unveiled May 27, 1956, at the estate of Mr. and Mrs. Louis Kocurek, Sr.

Sons of Louis Kocurek, Jr., life-size bronze garden portrait, *circa* 1960, at the estate of Mr. and Mrs. Louis Kocurek, Jr.

Mirabeau Lamar, bronze bust, *circa* 1945, in the Alamo Library on the Alamo grounds.

The Magnet — Mother's Arms, plaster bust, *circa* 1940, not commissioned, in the studio on Melrose Place.

Dick Prassel, bronze bas-relief, 1966, unveiled August 12, 1966, at Prassel Manufacturing Company.

After the Bath (also called Saturday Night), 4'5" plaster statue, 1946, in the studio on Melrose Place.

Youth Reflects, plaster life-size statue of her niece Waldine Schlather, for her New York debut in 1923, presently in studio on Melrose Place.

WACO, TEXAS

Pippa Passes, bronze life-size ultra-relief, 1956, unveiled September 28, 1957, in front of Armstrong-Browning Library on Baylor University campus.

WELLESLEY, MASSACHUSETTS

Innocence, the Ideal Head, small bronze head, 1930, at Wellesley College.

INDEX

fair in, 19; people in, 29; Waldine returns to, 36-37; no artist in, 39; considers Waldine great, 40; prides itself on Waldine, 79; clubwoman from, 88; girl friends in, 89; Waldine goes to, 90; Waldine lectures in, 91; Gulf Breeze located in, 159

Brady Tuesday Club: suggests fund raising for Waldine's art education, 15; begins raising money, 21; shops for Waldine, 26; funds run out, 36; greets Waldine, 37; plans exhibits, 39; secures Waldine's first commission, 46; parallels Dr. Buckner, 121; raises funds for Browning statue, 124; excellent contacts, 124; asks Waldine to submit interpretation of *Pippa Passes*, 125; Dr. Armstrong writes to, 126; charter member of, 131

Browning Library: proposal for statue in front of, 124; half of funds raised, 125; founder of, 126; renamed Armstrong-Browning Library, 131

Browning, Robert: collection of writings of, 124; favorite of Waldine, 124; interpretation requested of *Pippa Passes* by, 125; his Pippa, 126; song from *Pippa Passes* by, 132

Brownwood, Texas: Waldine's first commission in, 46; Waldine lectures in, 91; MacArthur statue arrives in, 149; sculptures in, 159

Buckner statue, Dr. Hal F.: Waldine receives commission for, 121; photo of, 122; Waldine finishes, 124; donation of plaster cast of, 145

Buckner's Ranch for Boys: in Burnet, Texas, 121

Burnet, Texas: Buckner statue in, 121, 160

Calhoun Hall: 151

Calhoun, John W.: plaque of, 151, 154

Callaghan, Bryan: mayor of San Antonio, 33

Canary Islanders: assist in sponsoring un-

veiling ceremony for Moses Austin statue, 103

Canton, Texas: Van Zandt statue in, 91, 160

Canyon, Texas: sculptures in, 143, 145, 160

Carrington, Joy: designs certificate for Sir Winston Churchill, 134

Caruso, Josephine Lucchese: 73

Centennial Exposition of 1936: 143

Chapman Graduate Center: 143

Chapman, Mr. and Mrs. P. S.: 143

Chase, Major General William C.: gathers information on MacArthur, 145; approves MacArthur statue, 148

Chicago: Coppinis move to, 54; Waldine moves to, 58; activity in, 59; train ride to, 61-63; blizzard in, 64; Waldine and Coppini promote classical fine arts in, 69; Waldine speaks about, 70; Waldine learns lesson from, 72, 93

Chicago Tribune: announces war memorial plans, 58

Children Reading: bas-relief of, 79

Chuck Time on the Lazy R: painting by de Young in the St. Anthony Hotel's Rainbow Terrace, 105

Churchill, Sir Winston: accepts honorary membership, 134

City Council of San Antonio: HemisFair plans, 150; poor communications with Fine Arts Commission, 151; learns of Brackenridge statue, 151; accepts statue, 156

Classic Fine Arts Fraternity: formed as Classic Arts Fraternity, then renamed, 111; dissolution of, 113

Clinging to Youth: statue, photo of, 115

Cockrell, Mayor Pro-tem Lila: intervenes, 156

Comfort, Texas: Altgelt bust in, 160

Connally, Governor John: makes proclamation, 141

Contini, Cesare: helps in New York, 129; casts Texas Ranger of Today, 135; casts for Texas Centennial, 135; casts Douglas MacArthur statue, 149